"STARVING" TO SUCCESSFUL

The Artist's Guide to Getting Into Galleries and Selling More Art

J. JASON HOREJS

RedDot Press | Phoenix, AZ

To

My wife and partner, Carrie

My intrepid editor, Karly

And my mother and director, Elaine

CONTENTS

INTRODUCTION

I have been in the art business all of my life. One of my strongest childhood memories is the smell of oil paint and the sight of my father, a painter, in the studio hard at work on a canvas. I am the eldest of my parent's nine children – that's right, nine; and being the eldest, I got to experience the "starving" phase of my father's career.

My parents had decided to pursue a very unlikely career path, considering their surroundings. They were living in South-central Idaho, about as far as one can get from the center of the art universe. My father seemed to have some natural artistic talent, and with a little cultivation by his aunt Barbara, an avid Sunday painter, he felt he had found his vocation in life. My mother, an intrepid and indefatigable promoter, has always been his greatest fan, advocate, and business manager.

Being young and naïve, they must not have realized a career in art was an impossible dream, though family members and friends tried to warn them against their folly. I remember as a child realizing that people thought of my father as a crazy dreamer.

While growing up, I watched my father participating in weekend art shows, and holding down a day-job in the field of interior design. I saw my parents open their own art gallery in the small town where we lived, and watched them branch out to find representation for my fa-

ther's work in galleries around the country. He achieved greater and greater success for his work.

The last paragraph, however, belies the struggles they faced in pursuing their dream. I decided at an early age that the art business was anything but stable. For me, the "starving artist" image was more than just a stereotype: it was a reality. I remember when months would pass between the few and inconsistent sales of my father's work. It seemed a pretty sketchy proposition; my father in the studio painting for incredibly long hours, and my mother scrambling to make ends meet and keep food on the table. There were weeks where peach cobbler was served for breakfast, lunch, dinner and dessert.

I determined that I would pursue a career with a steady paycheck when I grew up — art was no way to make a living. Insurance seemed like it might be a good option.

By the time I was an adolescent, however, things began to change. My father seemed to have reached a juncture wherein he was creating enough work and showing in enough galleries to finally make a steady and comfortable, if not luxurious, living. Now that I was old enough to begin traveling to shows sponsored by his various galleries, this solitary, difficult path my parents had chosen could be seen in a different light: life had suddenly become an exotic and enviable adventure.

I was proud to watch sophisticated collectors come into the galleries to meet my father, and buy his work. To a kid from a small farming town, this attention paid to my father gave him an aura of glamour I had never imagined possible.

Early on, I realized I didn't have artistic talent, nor the artistic temperament. However, the gallery side of the business seemed a great way to be immersed in the art world, surrounded by art, while occupying a more suitable position for me.

By the time I was sixteen, in the early nineties, my father had set up a second studio in Phoenix, AZ, where my family would now spend the winters. I was hired to work in the gallery in Scottsdale where my father showed his work. I was put to work in the back room, where I would ship, help hang artwork, and do whatever odd jobs might be necessary to sustain a busy gallery.

After a few years in the back room, I was able to move out onto the sales floor. As soon as I made my first $10,000 art sale, I was hooked for life.

In 1998 I was married, and as a young couple often will, my wife and I began discussing what we wanted to do with our lives. Carrie was graduating with a degree in public relations, and had interned in a small art museum, writing press-releases and handling media relations. With this background, she too had a real interest in the arts.

We soon decided that if we were going to be in the art business, the only feasible avenue for us would be to have our own gallery. We devised a loose plan that would have us in our gallery by the time I was 35.

Over the next several years, we researched locations, networked with artists and wrote a business plan. It wasn't long before we reevaluated our time line and asked ourselves, "Why are we waiting?"

We knew we were going to face many challenges as we started our gallery, whether we did it when I was 35 or 27. Regardless of my age, the scenario would be the same: we would be pouring our savings and our energy into building the business from the ground up. Why wait until our mid-30's, when we would have children and fewer years to make our gallery a success?

We threw out our original plans, and proceeded to sign a lease on the most expensive real-estate we could find in Scottsdale, AZ. We took out loans, hired an architect and a contractor, and started bringing artists on board. Like my parents before us, we were young and didn't know we couldn't do it, so we did it.

In just under one year, we pulled everything together, built the gallery, and opened our doors. We hung the last of the art on the gallery walls on the evening of Monday, September 10, 2001. . .

We woke on the morning of Tuesday, September 11, revved up and excited to spend our first day in the gallery. I showered early, ate breakfast, and pulled out of the driveway with the intention of opening the gallery for our first big day.

I was a mile or two into my drive before I turned on my radio and realized the world had fallen apart.

Everyone remembers where he or she was on that sunny Tuesday morning, and clearly recalls the shock and terror of the events. Carrie and I felt the same emotions shared around the nation. We also felt a deep dread as the realization dawned that everything we had worked so hard for over the last several years was now in jeopardy. At that moment, we wondered whether our whole way of life had come to an end: it certainly seemed that our business, the art business, could not escape unscathed. Would people actually think about art, when something so terrible had happened to their world?

Despite the horrific news, we opened the gallery for business. What else were we supposed to do? The day was eerie; the streets were virtually deserted, the skies were empty, and, of course, not a single soul participated in our first day of business. We felt somber that night as we watched the evening news.

Wednesday morning was about the same—no one came in, and we sat at the front desk, having repeatedly

straightened and arranged the gallery. Just as we were about to toss it in and call it a day, a luxury car pulled up in front of the gallery, and a bejeweled woman climbed out and walked through our front door.

"I had to get out of the house," she exclaimed, "I needed to turn off the TV and do something beautiful."

We showed her around the gallery, and told her about our artists. After looking for a few minutes, she found a sculpture she fell in love with, and . . . bought it.

I never felt so relieved as I did at that moment. I realized that not only would people continue with their lives and buy art, but art could actually provide a means for healing; it could help people return to life and to a sense of normalcy. People still desired the beauty of art in their lives, and no terrorist attack, no matter how horrific, would dull that innate longing for that which is beautiful.

Launching a business post 9/11 was anything but easy. We were, however, able to begin to cultivate relationships with collectors, and to grow the gallery, in the days and years that followed.

Since opening the gallery, I have had the pleasure of working with hundreds of collectors, and dozens and dozens of artists. Perhaps it is because I grew up the son of an artist that I have always enjoyed my relationships with artists as much as my relationships with collectors.

In addition to the artists I represent in the gallery, I encounter many artists every month, who approach the gallery looking for representation, either in person, via email, or through the good-old-fashioned postal service. It is these frequent encounters with eager artists looking to market their work that have inspired the writing of this book.

Early in my tenure as a gallery owner, I learned to identify artists before they walked through the front door—they were the ones who looked like game, caught in the headlights. They weren't sure what to say as they approached me, and didn't know how to direct the conversation to representation. There were exceptions, but the majority had no idea about how to sell themselves.

Several years ago, with the gallery running smoothly, I realized there was an opportunity to help artists meet the challenge of successfully approaching galleries. I determined the reason for the difficulty these artists were experiencing: no one was teaching them the proper procedure. I researched and found a scarcity of practical information available to artists who were pursuing professional representation for their work.

An artist could go to school for six years and earn a Master of Fine Arts, read books on creating art, and take workshops to improve her talent and sharpen her skills, but was unlikely to find any instruction on how to sell her

work. Perhaps there was something I could do to fill the void.

I talked to successful artists, including my father. I asked what they had done to achieve their financial security. The more artists I talked to, the more it became clear that they, perhaps by a common instinct, had all done the same things. The more I analyzed their methods from my perspective as a gallery owner, the more I realized the information about those methods could be shared with other artists to help them walk the path to prosperity.

I first developed a day-long workshop with my mother, wherein I could share this information in an interactive setting. Then I began writing this book.

My goal in these pages is to give you an understanding of the art business, a concrete plan for systematic preparation in approaching a gallery, and the necessary tools to cultivate a relationship with the gallery owner/director. The express purpose of this work is to help you, the "starving artist", to sell your work by partnering with galleries.

PART I – LAYING THE GROUNDWORK

CHAPTER 1 | QUALITY

Let me take you with me, if I may, to a client's home not too far from my gallery in Scottsdale, AZ. The home sits on several acres of prime desert real estate in the heart of Paradise Valley, one of the most affluent areas in the state. Mr. Black (not his real name) had worked as an executive in a fortune 500 company in the Midwest, and when he retired, he and his wife decided they were finally going to have their dream home.

The Blacks spared no expense. They hired one of the finest architects in the valley, contracted with the finest custom home builder, and brought in top-notch interior designers and decorators. The effort shows in the 14,000 square foot home, which was completed several years ago. You walk into a beautiful marble and mahogany entryway, and are greeted by rich textures, beautiful Arizona light, and the finest craftsmanship you could find anywhere. Much of the furniture was imported from Italy — if you have never seen a $40,000 couch, rest assured, Italians know how to make a fine piece of furniture.

Finally, prepare to be stunned by the artwork gracing the walls and pedestals throughout the home. My clients have a range of pieces, some by deceased masters, and others by young, emerging artists. The subject matter

ranges from western art, to landscapes, to more contemporary paintings and sculptures, and even to old movie posters hanging in the home's private theater. While there is an amazing diversity of work, the consistent factor in evidence is the quality, the fine workmanship. No detail has been overlooked here. Frames on the paintings are all custom, many with fine gold-leafing. Bases are created from rich woods and marbles. Nothing looks out of place; the artwork fits right into the home.

As an artist, whether you are creating paintings, photographs, ceramics, bronzes, or any other media, you should be making a constant and consistent effort to improve the quality of your art.

I know I am breaking a taboo by saying this, but for just a moment I want you to set aside all of your ideas of what good art is — composition, creativity, vision, etc. - and think of your art purely as a product. I can almost hear the art teachers and the purists out there gasping with shock. I want to briefly take away the artistic and purely aesthetic considerations. Don't worry, I will let you have them back shortly. I want you to realize that to some degree you are creating a product, which, just like any other product, needs to fill the needs of a consumer.

Envision the homes, offices, galleries or museums where you would like your work to be displayed. You have to understand that your future buyers are looking

not only for a beautiful scene or a masterfully executed sculpture – they are looking for a piece of art that will reflect their taste and style, and project an image to everyone who enters their space. Because quality is the first item on the checklist, what is it that goes into creating a quality art *product*?

Materials

I am often approached by young artists who are just out of art school and looking to break into the business. The biggest mistake I see these young artists make is choosing to save a few dollars at the art store by buying inferior quality paints, primers, solvents or mediums. Remember, your work will reside with your collectors for years, and with their heirs for generations. Your reputation as an artist may ride on choices you make early in your career (no matter how old you are!) as you start putting work out for the world to see.

An investment in quality materials is an investment that will pay dividends throughout your career.

Finish

All I have to do is utter the word "framing", and I see artists' shoulders slump. No topic is more reviled, it seems, than framing, and understandably so. What could be more frustrating than to spend time and considerable

expense to frame a piece of artwork, only to hear, "I love the piece . . . but that frame has got to go"?

Framing can easily become one of your greatest expenses, but I encourage you to think of framing not as an expense, but as an investment. A great painting in a cheap frame is unlikely to sell. A less-than-great painting may very well sell in a high quality frame. Find a framer who considers his craft an art, and who will work with you to find the perfect frame for your work.

You should expect to spend between 10 and 20% of the retail value of your work on framing. (More about pricing later.)

Unframed, gallery-wrap canvases have become widely accepted for contemporary work, and for more traditional pieces. Even though the work is not framed, the same principles of quality apply. Make sure your canvas maker uses high-quality stretchers that will not warp or bow, and ensures that the canvas is well stretched and secured with durable fasteners.

If you are a sculptor, make sure you are basing your work with fine-quality, cabinetry-grade wood, or with durable stone that won't chip or crack in a collector's home.

Presentation

I recently heard the story of an artist who had been commissioned to create a painting for a collector in another state. The piece itself turned out beautifully, even better than the client had expected; imagine the impression the collector must have had when the painting arrived in a diaper box!

A collector wants to feel any piece she purchases from you is your masterpiece, the best piece you have ever created. A diaper box does not convey this message. Pack your work carefully when shipping. Though you may not be wearing white gloves when you hand-deliver a sculpture, you should act like you wish you were.

Action List

1. Perform a self-evaluation of your work. Line up 5-10 of your most recent works and ask yourself, "What are three things I could do to improve the quality of my work?" Try to see your work as a collector would. Turn the work around, upside down, and inside out (all right, perhaps not practical depending on your medium, but you get the idea).

2. Ask a trusted advisor for a similar evaluation. Invite an interior designer, gallery owner or a

local artist you admire to the studio for lunch, and in return for the lunch, ask him for a critique of the quality of your work. Don't ask what he thinks of your work –you need more specific input than that –but ask for three specific changes you could make to your work to improve the quality. An objective viewer is going to see things you would never notice in a million years – the input will be invaluable.

3. Make a plan to incorporate these suggestions into your production. It may not be possible to make the changes instantly, but plan to implement the changes over the next six months.

4. Make a commitment to a life-long pursuit of ever-higher quality. As I have spoken with successful artists over the years, quality is a constant theme. Visit a gallery, look at its most successful artists' work, and note the quality of the art. This is the excellence for which you are striving.

CHAPTER 2 | EDUCATION

Okay, you can stop thinking of your work as a product now – I know the strain was nearly killing you. Let's now spend some time talking about the quality of the work itself.

Several years ago, I was approached by an artist looking for representation in Scottsdale. As I was paging through his portfolio, he said to me:

> **No-No**
>
> "I've never had a lesson in my life" is not a badge of honor – Look for opportunities to expand your skill and knowledge.

"You're not going to believe this, but I have never had a lesson in my life."

As I turned from page to page, I silently nodded and thought to myself, "Actually . . . I do believe it."

I broach the topic of an artist's education gingerly. I have encountered many fine artists who have little or no formal nor academic training, and conversely, I have met many artists with multiple degrees whose work, frankly, did not excite me.

Education comes though as many different means as there are artists. I want to know you are serious about your art, and are striving to improve your technique and style – your collectors will want to know the same things.

When my father was in his early twenties he entered a major university art program and was excited to become endowed with the knowledge that would enable him to pursue his dream to be an artist. Imagine his disappointment when, on the first day of his first class, the professor stood up to welcome the eager young artists to his class.

"Welcome," he said (I'm imagining the conversation here, so this is more paraphrase than quote), "Welcome to painting theory 101. I am pleased to have you in my class and am pleased you have chosen to follow your passion for the arts. I want to tell you now to get this out of the way early- you cannot make a living as an artist. Let me repeat, you cannot make a living as an artist. What you need to do is learn how to teach."

You've probably heard a similar message at some point in your life, either from a well-meaning relative, or perhaps like my father, from a teacher. The "starving" artist stereotype is so deeply ingrained in the public conscience, people think they are doing you a favor by disabusing you of your naïve and misguided career choice. The message didn't sit well with my father, who was, af-

ter all, paying good money to attend art school precisely because he wanted to make a living as an artist.

My father made it through about a semester of school before he decided that the art program was not for him. He left school and went out to pursue his education in the world. He sought out artists whose work he admired, and who were making their living as artists. He took workshops, read their books, and attended their shows.

Of course, it is not my intent to discourage any artist from pursuing an academic education; but I propose it is only one of many paths to an artistic education.

Recently I conducted an informal survey of several hundred artists and asked them what they felt was their most important educational experience. Their responses are charted on the following page, and described in descending order of importance:

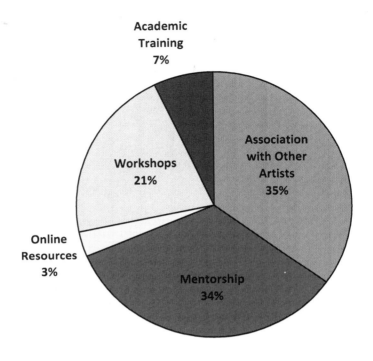

Academic
Training
7%

Association
with Other
Artists
35%

Workshops
21%

Online
Resources
3%

Mentorship
34%

1. Associate with other artists. It is no surprise
 this avenue tops the list of most valuable edu-
 cational experiences. Many artists have found
 there is a collective intelligence at work among
 groups of artists. Any question one has or chal-
 lenge he faces has already been surmounted
 by someone else, and often one can find that
 person without searching far.

Other artists with whom one associates w
so offer encouragement, networking opp
tunities, and insight into the market. They may
be willing to critique another's work and offer
suggestions of worthwhile classes.

Join an art guild or artists' association in your
area. You will quickly ascertain how valuable
the association will prove to be.

2. Mentorship. Working with an artist who has
 accumulated a lifetime of experience, while at
 the same time learning directly from her suc-
 cesses and failures, can prove incredibly bene-
 ficial in launching an artistic career. Many
 artists who have obtained some level of suc-
 cess are very generous with their time and
 knowledge. Look for opportunities to meet a
 local (or even distant) artist whom you admire.
 Seek an opportunity to meet, and ask if she
 would be willing to critique your work. Even if
 the artist has time to accommodate you, the
 critique may not turn into a mentorship; but
 this simple request for a critique has led many
 artists to mentor-student relationships. Every
 artist I have spoken to has felt his/her "ap-
 prenticeship" was invaluable in his/her artistic
 development.

3. Workshops. A workshop with an artist is a chance to experience a mini-mentorship. Hundreds of organizations around the country provide artists the opportunity to study directly with great artists in intensive workshops. Just a block from my gallery is one of the finest in the nation, the Scottsdale Artists' School; but one can find similar organizations scattered throughout the country.

4. Academic training. The intensity and discipline to be gained through academic training is hard to duplicate in any other way. The concentration on technique and the exploration of style and subject would be difficult to reproduce in self-directed study. It is no coincidence the majority of artists who have secured a place in history have had at least some academic training.

5. Online resources. The internet has revolutionized the art business in many ways, not the least of which is art education.

One may now watch lectures, take workshops and meet other artists from the comfort and anonymity of his own studio.

YouTube™ offers instruction to artists at every level, as does the public library if one is willing to search.

(Although not ranked in the top of the survey, certainly, worth mentioning.)

6. Reading. I confess I am an avid reader. Nothing has increased my knowledge of art, artists and art history like reading the biographies of the masters. As an artist begins to experience success and interact more with collectors, she will find she can greatly increase the depth of her relationships with them if she is able to have informed and intelligent conversations about art history and the important movements and artists who have moved the history forward. I encourage a competent command of art history from the impressionists through the present day, and the facility to be conversant with the movements and artists encompassed within each. But not-to-worry; one has her whole life-time to accomplish this education, and there is no final exam.

7. Travel: visit museums and galleries. A study of the lives of the great artists will reveal that most spent a good deal of time in museums, studying and copying the masters; and time in the galleries, studying and analyzing the work of their contemporaries.

As children, my brothers and sisters and I hated traveling with my parents. There we were in Los Angeles—but did we see Disneyland? Only what we could see out the window as we passed it on the freeway! We were too busy traipsing around galleries and museums.

Become a member of the local museum, and then make it a point whenever on vacation to visit the most important museums in the area.

8. Teach. Nothing expands the artist's understanding of her own work like having to explain what she's doing to a student. Whether teaching baby boomers who are just reaching for their inner artist, children, or friends, an artist's work will improve dramatically as she teaches.

On a side note, nothing proves one is a profes-
sional so much as teaching. Teaching art will
give the artist instant credibility.

9. Stretch. It is vital to take workshops by artists
 who are working in a medium, style, or sub-
 ject area that has nothing whatsoever to do
 with one's own artistic pursuit. The challenges
 experienced and approaches learned will invi-
 gorate and excite the student when she re-
 turns to her work. Creative batteries will be
 recharged, and work will be pursued in fresh
 and unexpected ways.

Knowledge is a powerful tool and motivator that pro-
pels one to a bright and successful future.

CHAPTER 3 | SUBJECT MATTER

Early in an artist's career it is natural to experiment, to try different directions and explore a wide variety of interests. This has to be one of the great pleasures of being an artist — no one can tell you what to be interested in, nor what direction to take.

Shortly after I opened the gallery, I was approached by an artist looking for representation. In her early fifties (I would guess), she had been classically trained in Europe, and evinced incredible talent. She had received many awards for her work, and had shown in European galleries in her youth to some success. But somehow she had never quite made the crossover into the American market.

Though in reviewing her portfolio I was captivated by the work, it simply was not a good fit for my more contemporary gallery. In spite of my effort to convey this fact as kindly as I possibly could, I could tell she was feeling a great deal of frustration.

"You know," she said, "I have been painting for thirty years; I am extremely talented- I can paint whatever you

want. You just tell me what is selling and I will paint it for you."

. . . This is *not* a successful strategy for approaching a gallery owner. I want to believe, as do my collectors, that you are so passionate about what you do that you have no choice in the matter. A collector's decision to buy your artwork will in most cases be driven by emotion, not logic. Experience has taught me that if I display artwork in my gallery that was created out of passion, I will sell it. Be true to your inner-vision as an artist and your work will attract galleries and collectors.

No-No

"I can paint what-ever will sell"

I have observed a number of artists who are constantly working to follow the trends. If one of the major art magazines were to run a series of articles on the popularity and importance of the red barn in contemporary American art, I guarantee artists of this ilk could be relied upon to approach the galleries four to six weeks later with their own flood of red barns. Artists who are trying to pursue the magical subject matter that will launch them into stardom are invariably disappointed.

Instead of imitating the current vogue, I encourage you to follow your passion. Then go out and find the galleries who share your passion for your work.

There are thousands of galleries and hundreds of millions of people in the United States. You cannot convince me there are not a number of galleries out there who would be excited about your work and able to sell it to their collectors. Create from your heart, and you will find collectors.

CHAPTER 4 | PRODUCE!

It may be early in the book to do it, but I am about to share with you the secret to success. I don't mean to offend you with a dirty, four-letter word here, but there is no other way to say it:

WORK

In fact the real secret is:

WORK, WORK, WORK

Yes, there's no way around it. If your goal is to be a successful, full-time artist, you must be in the studio constantly, consistently creating art.

My recent survey indicated artists who are selling $50,000 or more per year are, on average, creating 79 original pieces per year. For sculptors, the number was a bit lower because of the time necessary to create each piece; but even on the low end, the number was still 55. On the high end, one painter created 230 pieces last year!

Many artists upon first hearing these figures are stunned (perhaps you are a little stunned yourself). "Impossible!" you say, "I could never come close to creating

that many works in five years, let alone in one twelve month period."

Stop hyperventilating for a moment and do a little math with me; I can show you the importance of harnessing your creativity to create a large body of work. Let's suppose, just for argument's sake, your goal is to sell $120,000, which, after gallery commissions, would net you $60,000. Now let's work back from that figure. Let's assume you can sell 40% of the inventory you create in a given year (some years you may sell more, some less). You will need to create $300,000 in inventory to get you there. Let's say your average piece is selling at $3,000. Voila! You've just fallen nicely into my trap, and proven that you need to create 100 pieces to make this proposition viable.

I grant that I have simplified the equation, and I have not taken into account the cumulative inventory that will carry over from year to year; but you can easily see my point – if your goal is to sell your art for profit and make a living at this, you must create a lot of work.

"But wait," you say, "a few chapters ago you told me how important quality is. The quality of my work is going to suffer irreparable harm if I turn into a human art factory."

Exactly the opposite is true. You will find the quality of your work increasing as you put miles on your

paintbrush, burn up the film, crank out the jewelry, or rub your hands raw as you shape hundreds of pounds of clay or chisel your way through miles of stone.

Don't think of these figures and despair, and don't set unreasonable goals for yourself. Rather, survey your creations of the last year, and ask yourself what you can do to increase your production next year by 25%.

Several techniques you will find useful:

1. Set a consistent allotment of time every day, during which you commit to be in the studio creating; then stick to that schedule religiously. Consider your time in the studio sacred, and ask your family and friends to respect that time.

2. Set a goal to create a certain number of works per week. My father has long had the goal to produce two paintings per week. Some weeks it's two medium sized works, while others it's a large work and a study; but every week he diligently strives to get to that magic number, and every year he has completed over 100 pieces.

3. Get distractions out of the studio. If possible move the computer to another room, or at least turn it off during your studio time. I am

always amazed how I barely click "send" on an e-mail to an artist, only to have an instantaneous reply in my inbox. I figure one hand must be on a paintbrush, and the other on the keyboard. As technology has become more and more intrusive in an artist's life, the ability to sustain quality creative time has diminished. On that same note, turn your cell phone off. Studio time is a time for you to disconnect.

Of course, art history is filled with master artists who spent months to create a single piece – de Kooning and Hopper come to mind; so absolutely feel free to disregard this rule and create your masterpieces. However, to overcome the great marketing and business challenge you face when working slowly, you will need to become famous and sell at incredibly high prices.

One of my favorite art creation stories is Jackson Pollock's endeavor to create an eight by twenty foot mural for Peggy Guggenheim's apartment. Pollock had been commissioned to create the piece a year earlier, and Guggenheim was becoming impatient. Finally, she set a deadline for the work to be completed, and threatened to cut off his monthly stipend. Lee Krasner was living with Pollock at the time, acting as his de facto business manager, and despaired when the day before the deadline, the massive canvas still sat blank in the studio. Krasner went to bed certain of disaster as their only

means of income was soon to be withdrawn. She awakened in the morning, and went into the studio to find the finished piece: an incredibly complex, abstract composition.

This work is considered one of Pollock's masterpieces, and was created in about fifteen hours (unless you count the six months Pollock spent in his studio staring at the blank canvas).

* * *

Before you approach galleries, you should have 20-25 gallery-ready pieces in your inventory of two dimensional pieces, and 10-15 gallery-ready works in three dimensions.

By definition, a gallery-ready piece is fit for display upon a gallery wall or pedestal, and for immediate purchase by the client.

Don't expect a gallery to ask for all 10-25 of your pieces, as typically they only take a sampling of your work for display. However, you want to offer them a wide enough variety to provide a selection of pieces they feel will work best in their gallery. You also want to show them you have a sufficient inventory to rotate and replace pieces as they sell.

PART II - PULLING IT TOGETHER

CHAPTER 5 | SHARING YOUR VISION, CREATING YOUR BRAND

Ahh, branding — that clichéd catch-phrase that has been ever so popular with advertising agencies, self-styled marketing gurus, and hopeful business owners for the last ten years. I hesitate to bring the word into our discussion because the term has become so over-used. The principles are so important though, and the benefits of understanding the concepts so great, we must devote some time to formulating and implementing a brand strategy for your work.

To begin, it's important that we are clear about what a brand is. Some general examples will serve to start our discussion. Coca-Cola™ is recognized as the most valuable, universally recognized brand in the world. Consumers from every nook and cranny, beyond the far reaches of the globe, get a pleasurable sensation when they see that red and white logo.

Another incredible brand is FedEx™. As soon as you read the word, you think of speed, reliability and efficiency, don't you? A quite different image from the one that comes to mind if I mention the US Mail.

A brand is a collection of experiences and images associated with a service, a person, or a company, and just as a company name can create a strong brand association, so too can the name of an artist.

Think Georgia O'Keefe. Think Andy Warhol. Think Pablo Picasso or Jackson Pollock, or Monet.

The mere mention of these names instantly brings familiar images to your mind. As artists pursue unique and powerful visions, they establish brands in viewers' minds. You should work to do exactly that. You want to set your work apart from others to make your efforts instantly recognizable as your own; not as derivatives of other artists.

Several questions will help you begin to formulate a brand image for your work.

1. What is your primary target market?

2. What is your frame of reference?

3. What can you do to create a point of difference?

Understanding your Target Market

An artist's natural tendency might be to think of the art first, and the buyer last (if at all). This is a mistake. While you are not going to tailor your work to chase after a collector (see chapter 3), you will create a more powerful marketing and gallery strategy if you think of your buyer from the beginning. The more specific your vision of your future buyer, the better your ability to target her.

The best place to start is to look at your past sales. What are the common characteristics of your past buyers? Can you extract a common thread by analyzing the demographics of collectors who have already bought from you?

If you have good records of your buyers (or a good memory), you can start to answer questions like:

What is the average age of my buyer?

Do my buyers tend to originate from a certain region? Do they tend to be local, or from out of state?

What is their business background? Do I tend to appeal to people who have worked in a certain industry, or held particular positions within a company?

Am I selling to married couples or singles? If married, is the decision driven by the husband or the wife? If single, do I tend to sell to more women or men?

Is my work destined for homes or businesses? Does my work seem to fill a particular need within its ultimate destination?

Depending upon the number of sales you have made in the past, this may be a lengthy analytical process. If you don't have an extensive collector list, this analysis may not yield much valuable information. Either way, it is important for you to run through this process, and even more important to commit to gather this essential information in the future.

Each time you make a direct sale to a collector, make a point of asking as many demographic questions as you can; without, of course, sounding like you are giving the collector the third degree.

"Now, what line of business are you in?" is a great way to start. People love to talk about themselves, and will be flattered that you care enough to ask. These kinds of questions will serve a dual purpose: you will get valuable information for your marketing, and you will be building a deeper relationship with the collector, thus yielding additional future sales.

After analyzing past sales, it is important to consider to whom you would like to sell, and to classify the logical set of buyers for your work. If, like most artists, you are dissatisfied with your sales (and I doubt you would be reading this book if you were satisfied), it is likely due to the fact that you have yet to tap the right buyers.

Let's brainstorm for a minute, and tabulate some potential buyers for your work. This needn't be one sided; feel free to pull out a pencil and add your ideas to the list:

The Affluent	Public Institutions	Affinity Groups
Art Collectors	Hospitals	The Retired
Corporations	Hotels	Restaurants
Designers	Tourists	Golfers
Architects	Artists	Art Consultants
Professionals	Friends/Family	
New Home Buyers	Internet Buyers	

As you can see, these are in no particular order—and it is nowhere near an exhaustive list. You will also see that some of the categories I have listed are fairly broad – the affluent, for example – while others are more specific – golfers.

If your goal is to sell to the affluent (always a great place to start), your marketing strategies will be driven by the desire to get your work in front of them. You will

ask yourself where your target market spends their time and money. When would they be most likely to buy?

If your goal is to sell to affluent travelers, you should be showing your work in galleries in places like Jackson, WY, Aspen, CO, and Lake Tahoe, CA. Try to put yourself in the shoes of a well heeled traveler to anticipate where he is most likely to see and purchase your work.

Analyzing your Frame of Reference

Your potential buyer has a range of choices when considering an artwork purchase. You need to understand who your competition is as you set out to conquer the art market.

The internet has made it incredibly easy for you to analyze your competitors. All you need to do is sit down at the computer, and type some keywords describing your work into a search engine; in the blink of an eye, you will have a list of hundreds of artists with whom to compare your work.

Start a dossier with information about ten artists you consider to be your competition. I recommend a folding file, or a drawer in your filing cabinet, where you can compile accumulated information. Become a kind of private detective with the goal of examining what these artists are doing. You can learn a great deal from their experience.

Some questions you might pose:

Where is the artist from?

What is his/her background?

What is his/her education?

What does the artist's résumé look like? What about his/her bio and artist's statement?

What galleries is he/she showing in?

How does he/she advertise his/her work?

How is his/her work priced (this is critical, and we will come back to this when we talk about pricing your work)?

How is he/she presenting his/her work?

There is no reason for you to reinvent the marketing wheel. Learning from your competition is a powerful means to jumpstart your career.

"But wait," you object. "My work is totally unique. There is no one else out there doing what I am doing."

Sit down for this: I've got some bad news for you. There is nothing new under the sun. Okay, maybe you really have come up with a unique twist in how you are using your medium, or have invented a totally new style. Terrific. The next part of our exercise will be easy for you. If this is the case, you should look for other artists who are also doing something totally unique in their style, and are as far outside the norms of conventional art as you, and compare your work to theirs.

Cultivate a Point of Difference

With all of the other artists out there, to make your work stand out, you must find some aspect to distinguish it from the competition. Again, the goal is to create artwork that stands out from the crowd.

This is where pursuing your vision and finding your voice become so important. Find something you can do to accentuate the characteristics of your work that make it truly different. Do you have an interest in a unique subject? Is your use of color or medium unusual? Can you create a singular effect by framing or basing your work in an innovative way?

My father may serve here as an example. His impressionistic landscapes, wildflowers, and still-lifes are beautiful, but perhaps not entirely unique. Many years ago while visiting an artist friend in Seattle, he was struck by an idea whereby he could create a unique presentation

for his work. My father's friend was a contemporary artist, and had developed a custom box-stretched canvas for his work. He stretched the canvas over two-inch-thick wood stretchers, primed the canvas, and then used masking tape to mask off a ¾" border all the way around the painting, before adding another layer of gesso. He would then create his abstract work on the surface, and when the piece had dried, would peel the tape away to leave a clean border around the painting.

My father was intrigued by the technique. He saw that he could use the same technique to set his more traditional work apart. He went back to the studio, tweaked the concept to fit his purpose, and began painting on the new canvases. The effect was powerful. My father's work suddenly went from being just another landscape to being a traditional work that would fit into a contemporary (or traditional) home. Further, a collector interested in his work could instantly identify the paintings as my father's by the presentation. He uses the same basic design to this day, some twenty-plus years later.

Wildflowers by John Horejs

Your goal is to give a collector or a gallery owner a unique touchstone to identify your work. Of course the most important point of difference needn't be something external to the work, but can simply be a unique style, subject or treatment.

CHAPTER 6 | PRICING YOUR WORK WITH CONFIDENCE

One of the most common questions I hear from visitors to the gallery, and it's usually asked with a look of consternation, is: "How do you come up with the prices for the art?"

What a great question! I know exactly why they are asking it, too. It's because they have been in 20 galleries (there are over 40 on the street), and they have seen work ranging from $250 to $2,500,000. Quite frankly, it can be difficult for the uneducated eye to tell why the decimal is placed where it is.

This same question, in a slightly different form, is also the most common question I hear from artists. "How should I price my own artwork so that it will sell?"

Let's face it; it's a mystery, because there really is no rhyme or reason to the value of art. The intrinsic value of art is ephemeral; the true value is in the eye of the beholder.

This is such an important topic that I feel a little like Moses coming down from the mountain with stone tablets in hand. While the recommendations that follow are not biblical, I present you with:

The Commandments of Pricing

1. Always refer to the price of your work in terms of retail value.

 Whether you are talking to a gallery owner, a visitor to a show, or a private collector, you should have one consistent price for any piece of work. You are making a huge mistake if you feel that you can sell to buyers outside a gallery setting at a "wholesale" or "studio" price. You are undervaluing your work by doing so, and worse, you are undermining your galleries' or future galleries' ability to sell your work.

 It would be helpful for you to think of the value of your work in two parts. The first part of that value is the value you create in the studio as you employ your artistic talents and skills to create a masterpiece. You deserve to be paid for the effort it takes to create this value. The second part of the value comes from the effort that it takes to market and sell the art. There is a tremendous amount of time, work, and skill invested in making a sale happen, and the value created here needs to be

rewarded as well. Most artists I work with agree that in most cases it is easier to create the work than it is to sell it. (If this were not the case, you and every other artist would already be fabulously wealthy and, again, unlikely to be reading this book.)

If you sell a piece of artwork through your own efforts, you have earned both halves of the value of the work. If you turn the sales half of the process over to a gallery so you can devote your time to creating, the gallery earns the second half.

Let me say it again: do not under-value your work by quoting it at a less-than-retail price. Not in any circumstance.

2. Be consistent when pricing your art.

Thirty years ago, an artist could price art-work almost arbitrarily to adapt to cir-cumstance. An artist from Indianapolis could price an artwork at one price if sell-ing locally, and a completely separate, and usually higher price, if selling in another market.

41

The prevailing logic was that there were higher expenses involved in getting a piece to Florida, say, than would be incurred by hand delivering it to a gallery in Indianapolis. Not to mention the fact that buyers in Florida are generally in a higher tax bracket, and can afford to pay more.

The internet has made this practice impossible. The concept was always tenuous, in my opinion, but the internet has made it impossible to put into practice. You can bet your buyer in Florida is going to be on the computer the second he or she gets home after having seen your work, and is in essence going to have access to your entire inventory and pricing with several clicks of the mouse. Nothing is going to infuriate him/her faster than feeling he/she has overpaid for your work. Creating long-term success for your work demands you price your work consistently.

Another aspect of this principle is to raise the prices on your entire body of work if you institute a price increase. Your work already on the market should climb to the new price, lest you confuse your collec-

tors, who will not know which work is new versus old.

3. Institute a pricing formula.

This one should be a no-brainer. Why would you torture yourself by having to figure out the price of each piece as it is created? You will drive yourself to drinking; and worse, you will lose sales to confused buyers who can't make sense of your pricing. Remember a buyer, especially a novice, is looking for reassurance about his desire to buy your work. Confusion about your pricing will create too much doubt in a buyer's mind – I've seen it happen – and instead of a sale, you will have a collector walking out the door.

Painters: Price by the square inch. There is simply no easier method to consistently price your work than by size. A collector may not realize he is paying by the square inch, but it is quietly reassuring to him that the larger the painting, the higher the value.

43

Figurative painters: Price by size; but add one more variable—the number of figures.

Sculptors: Take your casting costs, times them by three or four, and set the result as your retail value.

Photographers: Price by the size, factoring in the number of prints. The higher the edition, the lower the price per print.

Fine Art Jewelers: Price by the cost of your materials times four. If you create intricately detailed work, you may also factor in your time.

The idea is to have a formula so simple you could hand it to someone else, and with a few variables, she could come up with your price.

4. Research comparable artists.

Now we come back to the dossier we created in the previous chapter as you began to research your competition. One of the most important factors in your analysis is the pricing structure your competition has in place. After cracking the artists'

formulas for pricing (I will guarantee most of them are using the methods I mentioned), it's time for you to determine how to position your pricing in comparison to the competition.

Create a spectrum of the prices you find. Place the lowest price on the left and the highest on the right; then plot each of the artists you are researching on the chart. Once you have done this, you will have a clear picture of your competition. Now draw a line in the center, and somewhere close to this centerline is where you want to be priced.

The tendency of an artist who is searching for a price is to start lower than the competition. This is a mistake. Under-pricing your work can be just as detrimental to your sales as over-pricing. Often a collector will fall in love with a piece, but if the price is too low she begins to question her taste.

The economic downturn (recession, or depression, call it whatever you will) of 2008 bore this out for me. Going into the slowdown, I thought it would be impor-

tant to stock the gallery with lower-priced works. I talked to several of my artists and asked for smaller works — anything that could be sold at a lower price-point. My thought was that even if a collector couldn't afford to buy a large piece, at least he would be able to fill his desire to buy something with a smaller piece, and we could make up in volume what we were losing in magnitude.

This proved completely backward. Instead of beginning to sell lower priced work, the low-end fell off almost completely. Through the slowdown, the *only* work we were selling was at the high end of our offerings. Life-size bronzes, paintings by our most renowned artists, photos, ceramics and jewelry at the highest price points continued to move, while the lesser-priced sales came to a grinding halt.

Looking back, even though somewhat counterintuitive, the phenomenon makes sense. The buyers most likely to be attracted to the low-end were too busy worrying about their jobs, their homes, and their shrinking 401(k)s to even notice art. My collectors at the top of the income

spectrum, though certainly hurt, were best insulated to weather the storm.

Remember, pricing is arbitrary – your art is worth what you are asking for it.

One last clichéd anecdote and then I'll move on. A jeweler was once asked what he did if a particular line wasn't selling.

"It's simple," he replied, "I raise the price."

5. Don't price your work at local prices to the detriment of national sales.

 "But I live in _____ (you fill in the blank), and in _____ (fill it in again), we can't get the kind of prices you are talking about. We just don't have a strong art market here."

 First, it is amazing to me that I hear this exact line, no matter where I am. I believe it is a variation of the grass is always greener mentality, and is a moot point. If you can't price your work where it should be priced simply because it won't sell in your local market, the solution is simple: don't sell in your local market. And you would be amazed how many successful

artists there are out there who do not sell their work in their hometowns.

If you simply cannot sell your work in Cleveland because the art market won't bear it, find galleries in markets that will bear your prices.

6. Don't lose money.

This commandment seems almost too elementary to mention, and yet it must be because it might be the most often broken of these particular commandments.

The truth is simple, if a little harsh. If you are not profitable in your artistic endeavors, you are a hobbyist, not a professional.

Track your sales closely, and track your expenses. If there is no significant margin between the two, it is time to determine how to cut your expenses or raise your prices.

I had an artist talk to me about sales several years ago, and I could hear the frustration in her voice.

"I sold a tremendous number of pieces in the last twelve months and I was thrilled, until I sat down and did my taxes. I had worked myself nearly to death; twelve hour days in the studio and numerous shows and endless marketing, only to realize I could have made more flipping burgers in a fast food restaurant."

While painting may be more glamorous than fast food, the point is well taken. And while it is tragic this artist's work wasn't bringing her the kind of income she probably deserved, what's even worse was her not knowing this until well after the fact. Keep careful tally of the materials and time expended in your work; then make sure you can recoup your costs when work sells, together with enough to compensate your efforts.

7. Do not over-price.

I've spent a good part of the chapter convincing you your work is under-priced, and that you need to profit from your sales; now I need to hit you from the other side. I'm certain you've been pretty excited to learn you are underpriced and just need to

raise your prices to start selling more. I stand by this strategy if you truly are under-priced, but **don't over do it!** I have advised artists to increase their prices and watched in amazement as their valuations doubled or even tripled.

Remember, you need to be comparing your work to artists who are comparable. Don't compare your pricing to Lucien Freud unless you, too, are world famous, in museum collections, and pulling up to your shows in a limousine.

Also, remember once you have raised your prices you are married to them, especially if you have sold a piece or two. Raise your prices if necessary, but be reasonable about it – you can always raise them again in six months, or a year down the road if work is flying out of your galleries. Incremental increases are most effective.

8. Don't over-analyze – if you're struggling, just pick a price and move forward with confidence

I am reminded of a young artist I met who was struggling with price. To solve the problem and end his insanity, he and his wife finally wrote a range of prices on a sheet of paper, cut the paper into small squares, folded them, and placed them in a hat. The number they drew became the factor by which they priced his work.

I'll say it again. Pricing is completely arbitrary. Select a price based upon your competition, your profitability, and your goals. Once you have done this, get behind the price and push your work in markets that can bear the value.

9. Review your pricing regularly.

Every year, either at the beginning of the year or at tax time, sit down and analyze the past year's sales. Look for trends in subject matter, or sizes that sell well. Determine which of your galleries are your most profitable. Re-analyze your competition. The equation at this review will be

51

simple – if you are having a hard time keeping your inventory fresh in your galleries because they are moving too much work for you to keep up, it is time for you to raise your prices by 10-15%.

All right, there aren't ten of these commandments, but you now have a clear idea how to price your work with confidence.

One final note on pricing. I am frequently asked whether it would be appropriate to have a conversation with the owner of a gallery you are approaching, to ask her how she would price your work. While this might seem like a good idea, I don't recommend it. You are striving to convey the impression you are a professional. By asking what the gallery owner thinks of your pricing, you are relaying two damaging messages. The first is that you are not as prepared or as professional as you need to be. The second is that you haven't sold enough art to establish a market value.

> **No No**
>
> Don't ask for help pricing your work from a potential gallery

CHAPTER 7 | CONTROL YOUR INVENTORY BEFORE IT CONTROLS YOU

I will give you another magic word which has been consistently mentioned as I have interviewed artists. Most artists don't particularly like to be, but if you are to be successful, you have to:

Be Organized

I can sense you cringing and squirming. After all, if you had the ability to be organized, you would have become an accountant, not an artist. I get it. Because you spend most of your life on the creative right side of your mind, what business do you have trespassing on the analytical and organized left side? I suspect some artists have completely lost access to the left side of their minds (you know who you are).

If, however, you cannot pull yourself together and get organized, you are going to be buried in a mountain of inventory, and that avalanche is going to keep you from achieving your full potential as a professional artist. Remember, you're working toward a goal of creating dozens of pieces per year – you've got to have a way to keep all of that work under control

My first suggestion is that you systematize and then digitize your record keeping. Get into a routine of cataloging each piece of work as it comes out of the studio, and make sure you have procedures in place to track work as it moves from studio to gallery, and then from gallery to gallery, or enters that blessed state of being sold.

A computerized inventory database will allow you to keep all of your vital statistics in one place. A good art inventory software will enable you to create inventory numbers, record title, size, medium, edition number (if necessary), price, and creation date. It will also let you organize images of your artwork.

The most important function of the program will be to track the location of each piece of artwork. The program should be able to print consignments, packing slips, and invoices.

I offer inventory software on my website; visit www.xanadugallery.com, or find other options available online. The key is to choose one that keeps track of everything you need it to, and does it in a simple, straightforward way. If your inventory isn't already computerized, your life will improve dramatically when you start working digitally.

Once you are digital, you should take a few more steps to make your life and your galleries' lives easier.

Inventory Number

Physically affix your inventory number to each piece of artwork. Write it on the stretcher, the matt, or the frame. Grind it into the base or the setting. You may have to get creative, but if you can find a way to consistently affix your inventory number to each piece, in a standardized location, you will never mix up a piece of artwork again.

On a side note—if you haven't been using inventory numbers already and need to start, don't start with the number 1. For the same reason no one orders checks to start at 1, you want to start with a nice, beefy, unrounded number like 3332.

Additional Artwork Information

In addition to the inventory number, you should attach other inventory information to your artwork in a permanent way. Include the title, your name, the size of the work, and the medium. Again, your galleries will thank you for making their lives easier.

You will notice I omitted a couple of items from those listed to attach to the artwork. The first is the price. You should exclude the price to avoid problems you might have if the value of your work changes. Imagine a collector who buys your work, takes it home, and notices on

the back a price of $5,000. No big deal, except he just paid $6,000 for it at a gallery. No explanation by a gallery owner that your prices have increased, and this is an older piece, will satisfy the collector who now feels he has paid too much. Because your prices are going to be raised across the board, including those on older works still on the market (see the previous chapter), this scenario is inevitable.

The second omission from this list of items to attach to the work is a date. **Do not date your work.** I can hear another gasp, as once again, I am recommending you flaunt conventional wisdom. I don't make this recommendation lightly. Years of experience have taught me that not only do dates not serve any useful purpose, they can actually hamper my ability to sell your work.

I once had an intriguing, one-of-a-kind sculpture that attracted a lot of attention. Visitors couldn't pass by the sculpture without becoming captivated and asking a question or two about it. Usually with a work that gets this much interest, selling it is just a matter of time. In this case, however, I was stymied as the question came time and again, "This was created in 2002?" The date was etched prominently into the sculpture, next to the artist's name. While no one ever said it aloud, the implication was there: "Why has this piece been around for so long and never sold?"

Maybe some people won't care, but if it causes you to lose even one sale in ten years, is it worth it? No.

I already know what your objection is going to be. "What about copyright?" Here I will refer you to your copyright attorney; but you will find your work is protected by copyright law automatically, whether you have the date on it or not. All you need to do is prove you have a way to track the creation date. Your inventory number and inventory software will allow you to do this very effectively.

"Okay," you continue, "but what happens when appraisers, or my posterity, want to know when a piece was created?"

You'll be dead, so what does it matter to you anyway!?

Your estate will have access to your incredibly well organized records, and will instantly be able to track the creation date by referencing your inventory number.

Always Ship Work with a Packing List

When your gallery unpacks your new work, and has it lined up against the back wall where it instantly attracts the attention of a collector, imagine how pleased the gallery staff will be when, asked the price of a particular piece, they simply pull out the packing list you provided,

to share the information with the collector. Your galleries have enough to do selling your art, without spending half their time trying to figure out what's what with your work.

* * *

An effort to get organized will simplify your life. If you can't do it, you should consider hiring someone who can, or employing the services of an intern. Organization provides more freedom for you to create.

CHAPTER 8 | CREATE CRITICAL COLLATERAL

In 2005, the gallery had grown to a point where we were ready to take our marketing efforts up a notch. Up to this point, we had been creating most of our own advertising. We began interviewing marketing firms around Phoenix, looking for one that would understand our goals and help us increase both traffic to the gallery and sales for our artists.

Fairly quickly, we found an agency with whom we felt we could relate. They met with us in their beautiful office space, and scheduled several sessions for us to talk about who we were as a gallery, who our customers were, and where we wanted to go. They really seemed to capture our vision and our direction. We indicated we were ready to proceed with them, and were anxious to see what they would come up with for us.

The firm calendared a follow-up meeting the next week, when they planned to show us some initial concepts. They wanted to rebrand the business, and felt it was important to start with our stationery design. We agreed to return a week later to see what they had for us.

I am not exaggerating when I say we were blown away with the concept they envisioned. The new stationery was to be created on velum, with our four-color logo at the top. Running through the paper was a swirling, spinning line that matched the theme of the logo. The matching envelopes were also printed on velum. A customer who received a letter with images from us would be able to see the artwork before ever opening the envelope. We had never seen anything as beautiful, and knew we had found our marketing team!

Then they handed us the printing estimate . . .

Now let me tell you, I am no stranger to printing costs. We had already run stationery when we opened the gallery, and had also run postcards and brochures. I understand that to make an impression one has to make an investment; but all we were doing here was creating one ream of letterhead and accompanying envelopes - $800, $1,200, $2,000? How much was a new business image worth?

$9,873.

At least that is what they tried to tell us. $9,873 for 500 sheets of stationery and matching envelopes, and that didn't even include design fees.

After they picked me up off the floor, we had a long and deep discussion, and I realized perhaps this company

didn't understand us as well as we had hoped. If they thought our business could afford to spend nearly $10,000 on paper – now keep in mind this wouldn't bring one additional customer in our door- they had another thought coming.

Very quickly, we realized the firm was accustomed to working with large corporations with mountainous advertising budgets. They may have had some tremendous ideas, but we would have been bankrupt before they ever could have been implemented.

I share this story with you because at some point you may face a similar temptation. You may think that in order to make it, you need to pour money into creating ad materials, or into expensive advertisements. Resist the temptation.

Below you will find a list of collateral materials you might consider creating for your artwork, and the degree of importance these materials hold toward your success in approaching galleries. I am going to list the items I feel least necessary first, and explain why, and work my way up to the more critical. I have rated each with a five star rating system – one star means the item is optional and unimportant in approaching galleries, while five stars signal that the item is critical and warrants your dedication of time and resources to producing it.

Business Cards ★★★ are fun to have and make you feel professional; and let's face it, they're not awfully expensive. On the other hand, they are not going to be the deciding difference between getting into a gallery, and not. The truth is, you hand me a business card, and it's going to float around on my desk for a few days, before it disappears forever into a Bermuda triangle of flotsam that is my filing system. I don't have a rolodex for cards, so my policy when an artist hands me a card is to save myself some time, and throw it directly into the trash. If you want me to have your contact information, send me an e-mail.

Brochures ★ are absolutely critical if you are doing art festivals or weekend shows. You want to have something you can hand to a collector so that he can walk away with images of your work, together with your contact information. When you approach a gallery, however, the brochure becomes next to worthless. A brochure is even worse than a business card, because it creates more mess for me. If I should choose to represent you, I can't use the brochure for my clients because: a.) it has your contact information, and b.) it won't match my branding.

I worked with an artist who produced an incredible brochure, and spent many thousands to do it. It was so nice, I even consented to hand some of them out to my collectors because he didn't put personal contact info on it. The problem, of course, was the brochure's inability to

keep up with new work. Within several months, the brochure was already feeling dated, and soon we weren't handing it out anymore. I was in the artist's studio in Utah a few weeks ago, and saw several boxes of the brochures sitting in the corner collecting dust.

You may have an opportunity to share costs on a brochure with your gallery. This route would make more sense, both for you and the gallery.

Postcards ✶. The same issues apply here as those listed for business cards and brochures. Again, if you are doing your own direct marketing, they make sense; but if your goal is getting galleries to do the marketing for you, there is no logical reason for you to spend a lot of time or money on postcards.

Artist's Statement ✶✶✶. I have read a lot of terrible artist's statements over the years, and have almost stopped reading them altogether. I still recommend that my artists put the time and effort into creating the statement, so that I can share it with my collectors. The statement is a summary of what your approach to your art is, what your philosophy is . . . in essence, it's why you think you are wonderful. You can see where there could be some potential for going a bit over the top.

I considered including one example of a poorly written statement here, illustrating the point;, but I am afraid the internet would make it too easy to trace back to the art-

ist. My intent is not to make anyone feel bad, nor end up in a law suit; so I'm not going to do that. I am including (with the permission of the artist) a statement which I feel does a good job.

Sample Artist's Statement - *Silvana LaCreta Ravena*

Silvana LaCreta Ravena is a versatile painter who works in oils, acrylics, watercolors, and encaustic. (She also creates wearable art.) Her non-encaustic work is both abstract and figurative, while the encaustic work is completely abstract. The encaustics, meticulous in their use of color and line, seem at first glimpse to be heavily influenced by Kandinsky and abstract expressionism, especially color field painting. But further acquaintance with Silvana's unique biography and the sources/inspirations behind her oeuvre, reveal an artist who has deftly marshaled passion, intellectual rigor, and solid technique to create a genuinely original body of work.

Silvana is originally from Sao Paulo, Brazil, and was educated as a psychologist. She also holds degrees in art therapy and art history. A practicing psychotherapist, her experience in the field led to the development of her signature artistic theme: memory. Further study and experimentation led Silvana to develop her own encaustic technique as a vehicle for exploring the subject.

As Silvana discovered, the hot wax used in encaustic painting, with its soft, pliable consistency is an ideal material for expressing the layered nature of memory. Before application, the heat binds the layers of wax to one another, creating a rich and complex surface. Then the wax, combined with pigment, can be liter-

ally sculpted upon the canvas, creating an infinite combination of textures.

Silvana's nontraditional technique brings further variety to her paintings through the use of custom made colors and additional manipulations of the material. With different wax mixtures, for example, she can give the raw material varying degrees of opacity and translucency.

"This whole art form is reminiscent of the process we use to store memories . . . It's an ancient idea—Socrates considered wax a metaphor for memory," says Silvana. The layers Silvana creates in her paintings are intended to bring the layers of memory to life; the paintings' textures are not merely symbolized, but are present on the canvass. The work is decidedly three-dimensional and demands a live experience—it is impossible to perceive the paintings' rich textures by seeing them online or in print.

Drawing upon her training as a psychologist and academic, she incorporates into her work a variety of theoretical ideas, thus infusing it with another range of textures, beyond the pictorial. Freudian concepts such as the unconscious, repression, and latent/manifest content are especially important to the encaustic paintings. Such a range of influences serves to broaden her work, giving it a more fluid, open-ended character that invites the viewer to appreciate it in his/her own unique way.

The unique combination of elements Silvana LaCreta Ravena brings to her work—artistic, personal, and professional—gives her the credibility of an original. While each individual piece of hers certainly "speaks for itself," when seen in the context of the artist's background, ideas, and singular technique, it clearly gains a degree of vitality and significance that indicates the true measure of the work.

Silvana's statement is perfect. It is concise, focused, and to the point. From it the reader gains a sense of who she is, what her work signifies, and her methods and techniques for working. The statement refrains from using superlatives and art jargon.

Limit your statement to one page, and ideally it will be even less. Organize the statement so the most important information appears in the beginning, realizing you will lose readers with each succeeding paragraph.

Your statement may be written in either the first or third person, but should maintain an air of formality above that which you might take with your biography.

Also, you may need several different statements: one tailored to your galleries, another directed toward juries, and another to the press.

Resume or Curriculum Vitae ★★★★ The resume is one of the most important, yet least read documents you will ever produce. I mean, really, who is going to read the whole thing from start to finish? No one. The resume, or *curriculum vitae* if you drink your tea with your pinky sticking out, has one job: to sit securely in a gallery owner's or collector's hand, and prove you are serious about your career.

A couple of key points. If you have led a dual existence, pursuing a career to pay the bills and put the kids through college, you should think twice about including much about that part of your life in the resume. If you are trying to prove you are a professional artist, including your aeronautical engineering education and experience is not going to help to do this; in fact it may send exactly the opposite message. The only exception to this rule is when that other career was a part of your story as an artist (let's say you are a former aeronautical engineer who creates sculptures of rocketships, for example).

Include not only your education and your shows, awards and accolades, but also a list of collectors, and (eventually) a list of your galleries. You may have to stretch a bit on your collector list at first. For example:

Dr. & Mrs. Spencer Williams
Private Collectors, Idaho

Looks pretty impressive, doesn't it? You don't have to tell me they are an uncle and aunt, and I'm not going to ask. This list of patrons is critical for letting your galleries and collectors know they are not making a mistake by buying your work because, look, other people have already purchased your art.[*]

[*] This may be a good time to mention that your galleries are unlikely to share with you the contact information of your collectors who buy your work through the gallery. Remember, all I own as a

Your resume should be no longer than two pages, and I honestly prefer the one page resume. Keep it to the point.

Biographical Sketch ★★★★★ People fall in love with artwork; they buy stories. The most common question I hear from visitors to the gallery, and I hear it dozens of times each day, is: "Where is the artist from?" Although the answer I give doesn't seem to make any difference, when someone is looking at a piece of art, this seems to be the burning question.

Why the need to know from whence the artist hails? When a person sees a piece of art for the first time, he or she is challenged to understand it, to categorize it, to make a connection with it. Knowing where the artist is from is a jumping off point on that journey to understanding.

Having spoken with many collectors about the artwork they own, I know that geography plays a number of important rolls. First, I always hear where they found the work. "We were vacationing in Carmel," or "we found it on a trip to Rome." Then, invariably, geography has an impact in the story of the artist: "The artist is a color-blind painter from Texas," or "she's a twenty-year old

gallery owner is my collector list. I protect the list very carefully, and you will find other gallery owners do the same.

sculptor from Montana." The more the collector can wrap his mind around the artist's story, the more likely he is to make an emotional connection and buy.

This is where a strong biographical sketch can help you increase your sales. I had a client from California visit the gallery in the spring of 2007. She was attracted to paintings by one of my artists, and we had a brief discussion about his work, before I handed her a copy of his biography. Normally a collector would have taken the bio home, read it, and if still interested in the work, called me back. This collector, however, sat down in a chair in the gallery, read the whole bio, and then bought three major pieces on the spot. I have no doubt the bio played a major role in reinforcing her love for the artwork, and driving her to a buying decision.

Think of your bio as a brief magazine article about you and your history. I recommend the bio be written in third-person, and run anywhere from 3-10 pages (although if you have a lot of story to tell, I see no reason not to make it longer). If you want to have an idea of what it should contain, pick up a copy of Southwest Art magazine and model your bio after their articles.

You should answer the following questions in your bio:

1. Where are you from? The bio can retrace your geography from your birth to the present day.

2. How did you become interested in art?

3. What kind of formal (and/or informal) training do you have?

4. How has your career developed?

5. What is your primary subject matter? Why?

6. What techniques do you employ?

7. What is your style?

8. Are you involved with any arts or charitable organizations?

9. What notable awards have you won? (Don't list all of your awards here; that's what a resume is for.)

10. What has been your motivation or inspiration?

11. What have others (the more notable the source the better) said about your work?

12. What do your collectors feel about your work?

Of course, the more creative you are, the better. Look for a unique angle to drive the article.

If you are not an adept writer (and why would you be? You're a *visual* artist, after all) find someone to write the article for you. A local free-lance writer might be inclined to trade writing service for artwork, for example. Or, you may have a friend or family member who has a flair for words. Put some real effort into this; your bio is an investment that will pay you dividends for years to come.

Here is an example of a bio I wrote several years ago for Robert Burt. At the risk of sounding a bit egotistical, I am fairly proud of the bio, and I enjoy reading it even now. Note how the narrative is built around the concept of trying to understand from where the artwork comes. Also note how I used quotes to give the reader a better sense of connection to the artist.

Sample Bio - Robert Burt, Artist

How much can one learn about an artist by looking at his work? A review of painter Robert Burt's latest pieces reveals a great deal about the soft-spoken artist's life and passions.

Abandoned adobe churches - deserted city streets from small towns in Mexico and South America - long, rolling, country roads disappearing into the distance. Each scene conveys a sense of peace and solitude, while at the same time, Burt's bold use of color and strong compositional elements convey the intense beauty the artist sees in the world around him. His paintings invite the viewer on a journey to explore a world that lies far from the hustle of everyday life.

Robert Burt's personal journey as an artist began in his childhood. Born in the 1950's in the upstate New York hamlet of Kingston, Burt showed an aptitude for art from an early age.

"My uncle lived in Manhattan and was an artist working in the advertising field," Burt recalls. "When I was eight or nine, he started giving me lessons in chess and, more importantly, in painting." Burt's interest in art flourished under his uncle's tutelage, and by the time he was in his teens, Burt was taking figure-drawing classes at a local art gallery.

In high school, Burt began taking summer classes sponsored by the Art Students' League of New York in Woodstock, the heart of a burgeoning artists' community. The young artist studied under Franklin Alexander and further developed his drawing, painting, and composition skills.

Burt went on to study fine arts at Ulster College, while continuing with summer studies at the Art Students' League. After leaving school, he began working in batik, an art form which originated in Southeast Asia. The batik artist creates designs on fabric by masking areas with hot wax and then dying the cloth. The coated area doesn't take the dye, and by coating different areas in wax and dying the cloth repeatedly, the artist can create complex, layered images.

Burt loved the technique for the bold compositions and strong colors he was able to achieve. He began selling his batik apparel in art shows and shops, eventually opening his own gallery in Lake Placid, New York, which he ran successfully through the early 1980's.

In the mid-eighties, on the recommendation of friends, Burt decided to move the business to Asheville, North Carolina. Within a few years, the shop had done so well he decided to open a second shop in Chapel Hill.

During this period, Burt had several important experiences that would move him toward a full-time career as a painter. In an effort to broaden his artistic work, Burt began painting on the silk, in addition to dying it. He also traveled for several months through Europe and Asia. Burt was deeply moved by the richness of the cultures and landscapes he encountered, and while in Amsterdam, having realized he needed a new medium to convey his experiences, he bought a set of pastels. Upon his return to the U.S., Burt began painting in earnest.

Through the late eighties and early nineties, though he still owned the galleries in North Carolina, Burt devoted more and more of his time to pastel work. He took six months to apprentice with Ben Konis, a well-respected pastelist living in Amarillo,

Texas, who showed Burt not only technique, but what it took to make it in the art world.

By the mid 1990's, Burt sold his businesses in North Carolina and moved to Santa Fe, New Mexico.

"I always loved the drama of the Southwest," Burt explains. "I chose Santa Fe because I wanted to be among the artists and galleries there, and because of the convergence of the Hispanic, Indian, and cowboy cultures. I love to paint the adobe architecture set along the small, winding roads around Santa Fe and throughout New Mexico." He spent a great deal of time on the road throughout the Southwest, gathering subject matter.

In Santa Fe, Burt soon made another important change in his artwork, moving from pastels into acrylics, which allowed him to better capture the bold colors of the landscapes, the people, and the architecture, and to work on a larger scale.

Burt spent several years developing his style, drawing upon techniques he used in batik, silk painting, and pastel to create bold color fields and a depth of vision within his paintings, which he achieved by layering colors. His subjects were varied, but most came from his travels, which grew more and more extensive.

In 2003, he saw photographs taken by a friend who had visited Peru. "I knew right away I had to go," Burt says.

He ultimately spent a month traveling through Peru, led by a guide who was happy to show him a Peru not often glimpsed by foreigners. They visited small villages and traveled by back roads into the Andes.

The sketches and photos Burt compiled while in Peru kept him painting furiously for some time once he returned to Santa Fe. "In fact," Burt admits, "Peru still finds its way into my work."

A sculptor from the Mexican state of Sonora, whom Burt had befriended in Santa Fe, saw Burt's love for Latin culture and scenery and invited the artist to visit his home village in the mountains of Northern Mexico. Burt accepted the invitation, and in the fall of 2004 the two made the journey to Huachinara, which is about five hours south of the Mexican border.

Burt quickly fell in love with the town and its people. Before the end of his visit, he bought land to build an adobe home and studio, which are now nearly completed.

"I can't wait to start painting there," Burt says. "The light is excellent for a painter; the air is incredibly clean, and the studio will have great views of the mountains." He plans to divide his time amongst Huachinara, Santa Fe, and the open road.

Burt's visit happened to coincide with a visit by the governor of Sonora. Burt and his friend were invited to join the governor and a couple of thousand Sonoran ranchers and cowboys on a two-day trail ride from ranch to ranch in the surrounding countryside.

Burt's friend had been working for several years to create an art and cultural school in Huachinara, and during the ride the governor laid the cornerstone for the building of the school.

Burt was invited to join the school's board, an invitation he readily accepted.

"I had fallen in love with the people of the Santa Madre Mountains, and I want to help them improve their lives," Burt says of the endeavor. "We want to be able to provide work, to

teach art classes, to bring money and prosperity into the communities of the mountain region. It is a wonderful opportunity to give back, to help others."

Burt taught his first painting class in Huachinara in December 2004, and found that students of all ages were hungry to express themselves through art.

"I started the class at 9 a.m. each day, and they kept me there until 9 p.m." Burt says. "I was exhausted, but it was rewarding; I developed many new friendships."

Burt's travels have led him to a wide range of subject matter. One canvas may depict the softly curving lines of a New Mexican adobe schoolhouse, and the next might show the winding streets of a South American village; but all of Burt's work invites the viewer to join him in the adventure of life.

"I start a story with each of my paintings," Burt says, "but I allow the viewer to join me in finishing the story with his or her own experiences and emotions."

For his part of that story, Burt employs bold colors, and reduces the scene to its most elemental and powerful components. Each painting vibrates with artistic energy and color, entertaining the eye and the mind. "I want to create paintings that convey a bit of mystery and adventure," the artist says, "but also the feeling of joy."

* * *

The Portfolio ★★★★★ The portfolio is the artist's primary tool in getting his or her work in front of potential collectors and gallery owners. The portfolio is going to be the first impression you, the artist, leave, and you want to leave the right impression.

You now have a selection of different portfolio formats. Twenty-five years ago, an artist's portfolio was exactly that: a large portfolio with photos slipped into plastic sheets. Now you can choose between many different formats, including Image CDs, hard or soft-cover books printed online, purely digital .pdf portfolios, etc. Each of these formats has something to offer, and each comes with drawbacks.

The CD filled with digital images of your work is an inexpensive way to get a number of your portfolios out there. You can burn dozens of CDs for just a few dollars, and they are inexpensive to mail. The drawback to the CD is that it is easy for me to throw away, without ever having looked at the images; and the truth is, I do this all the time. Looking at a CD is simply too much work for me in my busy life. I have to get it into the computer, close whatever else I was working on,

only to discover that you created the images on a Mac, while I am on a PC, so my computer doesn't want to open them. It's honestly more effort than I care to expend.

That's not to say you shouldn't create CDs of your work; they truly can be great ways to multiply your efforts, and get your work out to a larger audience. However, I recommend you use the CD as a supplement to your primary portfolio, and not as the primary portfolio itself.

The Digital Photo Book, which you can now print online inexpensively (visit sites like Blurb.com, or mypublisher.com to see examples) and professionally, is another option to consider. This book reproduces your work beautifully, and looks like it just came out of a bookstore. Nothing will stroke your vanity like seeing your work in print in one of these books.

The problem? Unless you are willing to republish and reformat your book every month or so, it is quickly going to be out of date. This would be another great supplementary item for you to sell at art festivals, but is not flexible enough to be your primary portfolio.

The disposable presentation folder, a simple report cover with 20-30 plastic sheet holders inside, is my favorite portfolio. You will find them at your local office supply store, and can use them to create a half-dozen

identical portfolios. Print the images from your high-quality home ink-jet, and insert the pages into the folder. You now have an easy-to-maintain, professional portfolio that will enable you to get your most recent images in front of your target audience.

Each portfolio page should include 1-2 images. With each image, you should include all pertinent information: title, medium, size, and price. Make it easy for me to know exactly what I am looking at.

I recommend you format your portfolio to make the images what the viewer sees first. Include 20-25 images in the portfolio, including several sold pieces, clearly marked as sold (or even better, show them in the settings of the owners' homes or offices). Place your bio, resume, and artist's statement at the back of the portfolio.

Sample Portfolio Page

Colors of October
by John Horejs
72" x 72"
Oil

$15000

Sample Portfolio Page – Sold Artwork

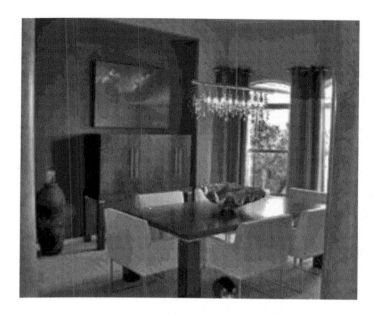

Sold to Private Collector
Fountain Hills, AZ

Artist's Website ★★★★★ This topic is so important that it gets its own chapter to follow.

Digital Images ★★★★★★★★★ I cannot over-emphasize how important it is that every piece of art-work coming out of your studio be captured digitally with a quality camera. The images are going to be critical to you and your galleries in marketing your work. These images will be used for websites, postcards, and newsletters.

Devise a setup in your studio that will allow you to take the photos yourself. You may need a simple cloth back-drop, and some lighting; or you may find you can use natural light, or even shoot in direct sunlight. Experiment to find the simplest means possible to get your work to look good on disk. There will certainly be times when you need a professional photographer to do the shot for you, as when you print in a magazine; but otherwise, your photography will suffice.

Keep the photos organized (this will be simple to do if you have implemented the inventory numbering system recommended in chapter 7) on your computer, and for heaven's sake, BACK UP YOUR IMAGES AND KEEP THE BACKUP IN A SAFE PLACE. I was sick to learn a couple of years ago that thieves broke into one of my artist's van, and stole his laptop. The loss of a laptop is a tragedy, but

imagine the pain the artist felt when he realized the images of his past five year body of work were stored on the hard drive, and nowhere else. True story. BACKUP!

Don't worry about standardizing your image resolution or sizes; simply store the raw file at its highest resolution, and resize images when they are requested by your gallery.

CHAPTER 9 | EXPLODE ONTO THE WEB

The internet has revolutionized the art market over the last fifteen years. There was a time, not too long ago actually, when it was thought the internet would simply be a reference tool for providing information about artists to collectors. No one believed that a collector would ever buy art directly from the internet, sight-unseen.

From the beginning, we wanted the Xanadu Gallery website to be revolutionary and cutting edge. We were one of the first galleries to make our entire inventory available online, rather than a mere few samples of each artist's work. Still, I resisted adding e-commerce to the website because I, like many other gallery-owners, held the notion that art needs to be seen in person to be truly appreciated, and actually purchased.

About two years ago, my gallery director, Whitney, started pushing for us to add a shopping cart to our site. I resisted due to the expense and time involved, and to my perception that it would lead to very few direct sales. Whitney was persistent, however, and eventually I gave in.

Within four hours of launching the shopping cart, we had a sale for over $8,000 to a client in Georgia who had never even been to Arizona, let alone to our gallery. She was searching online for artwork to fill a certain need, came across our website, and bought. I can tell you it took me quite a while to live down Whitney's I-told-you-so's, but I was thrilled to eat a little crow.

I don't want to give the impression that internet sales have taken over; they are only a small percentage of my over-all business, but they represent a growing segment of sales. It is safe to say, though, that not only will people use the web as a research resource, they will also buy art directly from the web.

Great! Terrific! You can now start your own website and sell your work directly to collectors, thus eliminating the need to even have galleries working for you.

Not so fast. If you already have a website, you know internet sales are not all they promised to be. The problem, of course, is that though you now have a way to directly reach out to collectors, so does every other artist who is willing to take the time to build a website. Collectors now have to work hard to find exactly what they are looking for on the web, and they must wade through a lot of . . . how do I say this delicately? . . less than professional artwork in their search. You have your work cut

out for you if you want to get your art to the top of the search engines so it can be found.

Galleries continue to remain relevant as they sift through the artists, looking for the work of highest quality. Galleries also continue to offer a safe marketplace because they stand behind the quality of the art and the artist, and they offer critical marketing support for their artists to ensure their work gets the attention it deserves.

So how can you make sure your website is doing the job it should be doing? As a gallery owner who looks at many artists' websites, I have formulated a strong opinion about what it takes to have a successful website that enhances your gallery relationships, and increases your sales.

1. Your website should project a **professional** appearance. You want a website that conforms to current design standards, is not distracting, and shows your art in its best possible light. In most cases, unless you are a professional web designer by night, you will be well advised to hire someone to design your site for you. You cannot afford to spend your time and energy building and maintaining a website, when your most valuable time is the time you spend in the studio.

2. Your website should be **up-to-date**. I am amazed when I come across an artist's website that boasts on its home page, "Last updated on October 4th, 2003." Are you kidding me? Does this artist not understand the concept of the internet? The internet is all about "now." If your website is not updated to show your most current work, it is not serving any real purpose. Collectors are only going to visit the site twice if you are not updating: first to see what you are all about, and second to see what's new. You're not going to get a third visit if you are not offering anything different. With this in mind, ask your web designer to please, please, please make it possible for you to upload your own images to the site. Nothing could be more frustrating than sending images of new work to your webmaster, and waiting for months for the images to appear on your website.

3. Keep you home page fresh. You should have images of new work on the homepage every week or two. The homepage is also a great place to share news about your upcoming events, thoughts about your artwork, and your stories of success. Again, the idea is to give a collector excuses to return to your site.

4. Give your collectors and galleries an extensive catalog of relevant work. Your portfolio is a concise look at your most recent works; your website is your opportunity to share your entire body of work with your viewers. Make sure the work is well-categorized, and the site easy to navigate, so collectors don't get buried in art, or frustrated in trying to find a particular piece; but there is no reason to limit the amount of work on your site. That said, you should strive to make sure you don't have work on the site that will detract from your current work. You don't want pieces from early in your career, unless they really show your genius. Nor do you want to display work completely outside the realm of your current body (a lonely abstract if you sell representation or realist works, for example).

5. Your website should work for you around the clock, collecting the e-mail addresses of your potential collectors. This is a valuable tool in building your marketing efforts, and in getting visitors back to your site.

6. Your website should not be competition for your galleries. Earnestly weigh whether you want to add e-commerce to your site. While it

may help you make a few sales over the years, it will certainly prevent you from getting into the galleries who do not want to be in direct competition with their artists.

If you currently sell from your website, use the sales as a means to get you into a gallery. As you contact galleries, tell them how much work you sold in the last year through the website; and let them know should they choose to represent you, all of your internet sales will be referred back to your galleries.

7. Become searchable. About six months ago, Carrie began a quest to optimize our website for the search engines. Search engine optimization is, and has been, all the rage among marketing companies, and web designers. It has become a garden industry with the specific task of helping businesses become searchable. Your web designer will understand the technical side of things, such as meta-keywords, page titles, and image tags; however, it is important that you give him guidance as to what is important to you.

 a. Put your name all over your website. It's not enough to have your name in

the logo at the top of the page (especially if it's part of a .jpg logo). Your name should appear in text throughout the website. With each artwork image, be sure to include "by John Doe". This repetition will enable your website to be the first to show up when a collector plugs your name in. Of course if you have a common name, you're going to have a more difficult time with this. But you can increase your results by putting the word "artist" near your name; the most likely search will be "John Doe Artist".

b. Think like your collectors. Which search terms would a potential collector use to match up to your work? The more specific you can be, the more success you are going to have in bringing qualified potential buyers to your site. In my mind, it is not as important to bring large numbers of visitors to your site as it is to bring the right visitors. "Landscape Painter" is not as specific as "Mountain Landscape Painter," or "Aspen Paintings." Be especially descriptive of each artwork in its alternate

91

text, and sprinkle keywords describing your work liberally throughout your site.

c. Get links out there. The search engines consider it essential that your site be regarded as important by other sites. They judge this by counting the number of links leading to your site. Look for opportunities to get your website posted on other websites and blogs. Exchange links with friends by agreeing to put a link to their website on your site, if they will reciprocate with a link to your site. Make comments on art-related sites or blogs, and be sure they post a link to your site. We have been amazed at how links have increased our traffic, and you will be, too.

8. Implement a mechanism for tracking your traffic. Other than sales, a web traffic counter will be the best way for you to judge the effectiveness of your marketing efforts. A counter can tell you not only how many hits you are getting on your website, but also where they are coming from, how much time they are spending on specific pages, how they found you, and

whether they are returning. Statcounter.com and Google both have terrific tools which you can install free of charge on your site.

9. Create an e-newsletter. While this is not technically part of your website, I include it here because this newsletter will be one of the primary drivers of traffic to your site. The benefits of a newsletter are in building relationships with your customers, and driving them to your site. As you build your mailing list, this newsletter becomes more and more effective at bringing burgeoning numbers of the best kind of visitors to your site: potential buyers who have already expressed interest in your work. Make sure an image is the first thing appearing in subscribers' emails. An image is worth a thousand words, and is your best chance to draw in a subscriber. Include news of upcoming shows, recent trips, and current efforts. Invite feedback.

It would be impossible to overstate the importance of your website, both for attracting buyers and getting into galleries. In the last year, we have taken on several artists who didn't approach us; rather, in seeking specific subjects and styles, we sought them out online.

PART III – ESTABLISHING A TRACK RECORD OF SALES

CHAPTER 10 | GET YOUR WORK OUT THERE

The name of the game, especially early in one's career, is exposure. You want your artwork out and in front of as many viewers as possible, particularly in front of your target market audience; so look for every chance to show your work in public.

I strongly encourage every artist to spend some time in the art show/festival circuit. Exhibiting in shows may be a major pain with all the work involved in setting up and taking down the show, braving the elements, making few if any sales, etc. But don't think of the show solely as a place to sell your art; think of it as a school where you can sharpen your sales skills as you learn what goes into selling your work. Art shows allow you to practice your contact and people skills with show visitors. Most importantly, you will build your mailing list. Just as your website will constantly be adding potential collectors, a guest book at an art show will give each visitor an opportunity to sign up to receive updates about your

work through the e-mail newsletter mentioned in the previous chapter.

Donate your work to charity events. These events provide a means to expose your work to a qualified clientele, and an opportunity to give back to the community. Resist the temptation to donate older pieces to the auction, or pieces you would not want to have on the market because of issues of quality or subject matter. You'll feel better about your participation, raise more money for the charity, and better build your long-term career if you dig deep and make the sacrifice of a great piece. You needn't overdo it; two to three donated pieces per year will serve to generously support your community.

Network with interior designers in your area by attending ASID events, and by visiting their showrooms.

Show your work in public venues. Many community libraries, hospitals, airports, and other publicly owned facilities show local artists on a rotating basis. I spend many hours in airports, and I always make it a point to visit art displays in the concourses.

Show your work online in web-based galleries. In addition to a personal website, you should consider showing your work in an online venue. A quick search of the internet will reveal numerous online opportunities. Find a website with a good Google page-ranking, and one that will allow you to include a link to your personal website. Understand that you should not expect a flood of sales to result from your presence online; in fact, it may not lead to any sales. But for a very low cost (anywhere from free, up to $20-$25 per month), you can increase your web-exposure, and drive more traffic to your site. Many of the sites boast high traffic counts; some in the millions per month. While much of the traffic is probably artists visiting the site, some percentage of the visiting traffic is surely comprised of collectors, designers, and galleries.

I suggest you **link your online gallery page to a specific page on your website,** so that you may track (see the previous chapter) exactly how much traffic it is generating. If you find you're not getting as much traffic as you would like, switch to a different online gallery.

Join your local art guild, art association, or arts council. Some of the benefits of these organizations were already mentioned in Chapter 2. Though I'll not repeat myself, do be aware that many of these organizations provide opportunities for member artists to participate in shows, often in association with museums, galleries, or other institutions.

Work toward membership in national juried associations. Signature members of such organizations as the Oil Painters of America, and the National Sculptor's Society, benefit from a large, and often loyal group of collectors. The organizations sponsor rotating traveling exhibitions around the country, thus giving their members opportunities for wide exposure.

While you should look for every chance to get your work out in front of the public, you should also realize this is not your end goal. To an extent, the process of gaining exposure is part of "paying your dues" as an artist. Many artists, however, consign themselves to paying their dues for far too long, some even spending their artistic lives bouncing from festival to festival and association to association, without ever getting anywhere.

Yes, the shows do help build your resume, and the awards you win do make nice footnotes in your portfolio;

but all of these efforts combined will only take you so far, and will result in limited sales. And though you may choose to maintain your memberships in particular organizations to build exposure even after you are showing in galleries, keep your goal in sight: Gallery Representation.

If you spend more than a year or two working to increase your bona fides as an artist, you will begin to experience diminishing benefits. I have met artists who have spent ten, fifteen, even twenty years "establishing" themselves. Not only has that effort kept them out of the studio, but a gallery owner is likely to look at their resumes and see years and years packed with show circuits and juried awards as indicative that these artists are career amateur artists, rather than serious professionals.[†]

You should also know that I have met many artists who have bypassed the exposure suggestions altogether, and headed straight to galleries for representation; and they have done so successfully. Even though they have missed some valuable educational experience, a certain amount of education and success in life comes from be-

[†] Don't panic if this paragraph describes you: there is a simple cure. Revisit your resume and do some radical surgery to cut it down to your most significant awards and your most recent activities. Then work to put an emphasis on your sales, and any gallery experience.

ing audacious. I would much rather see you head out into the art world too soon, than see you wait too long.

CHAPTER 11 | A CRASH
COURSE IN SELLING ART

Once you have the opportunity to show your work in public, especially at shows and festivals, it becomes critical that you develop salesmanship. When I occasionally attend these shows, I am surprised by the lack of basic sales skills exhibited by many of the artists I meet. I know this doesn't apply to you, but I am not sure these artists would last a single day in a retail setting. I am either ignored completely, or attacked. The artists go on and on about their work, or themselves, but never bother to ask my name. Finally I am allowed to leave the booth without having been asked for my contact information. One of the greatest evidences of the modern miracle is that any sale is made at these shows.

Entire libraries could be filled with books that have been written on the art of sales. My intent is not to belabor such well covered territory here.

I would, however, like to spend some time talking about selling art, which, while sharing many aspects in common with selling anything else, also presents some unique sales challenges and opportunities. The goal is to create a powerful relationship with a potential client,

convert the potential client into a customer, and build a lasting, profitable relationship with your new collectors.

1. Your first goal as you are working with a collector is to build a relationship of trust. Strive to make a personal connection that engenders an affinity and rapport. You can do this by viewing the person as a human being with interests and desires, unique thoughts and perceptions of the world, and valuable insights about your art. Make it your goal to learn as much as you can about the client, and to forge a new friendship with everyone you meet.

2. Introduce yourself. As soon as someone walks up to your work, you want to acknowledge him (or her) and introduce yourself. It's not enough to smile, nod, and say howdy. Instead, you should hold out your hand and say, "Good afternoon, I'm Jason Horejs, and I am the artist. Welcome." More often than not, the client will give you her name in return.

3. If not, ask for her name. This bit of data is the most important data you can collect when you are talking to a potential client. Don't let her neglect to share it with you. I am a fan of being direct, and if a visitor to the gallery doesn't

give me a name, I will extract it. "Now tell me your name?" I put a question mark at the end of the phrase to avoid sounding like an interrogator. Using this question/command has never failed me.

4. Commit your client's name to memory. "I'm sorry, I'm terrible with names." Have you uttered these words? Probably within the last month, if you are like most artists I know. A little laugh, a reintroduction, and everything's good again, right? Maybe, but when you are working with a client, the single best thing you can do to strengthen your relationship is to learn his name, and then **use the name often**. No sound is sweeter than the sound of one's own name, and the more you use your client's name, the more he feels you are really connecting with him. So use a couple of tricks I have found to be effective.

 a. First, say the name right back to the client when first you hear it. "Hello, I'm Bob, and this is my wife Darlene," says your client. "Darlene," you say, reaching out to take the wife's hand, "It's a pleasure to meet you." Then you take the husband's hand and say, "Bob, I'm

glad to have you here today. Let me tell you about my work."

b. Second, mentally repeat the names ten times within the initial minute of introduction. This is what it sounds like in my head: "Darlene, Darlene, Bob, Bob, Darlene, Bob, Bob, Darlene, Darlene, Darlene . . . etc." Luckily my brain will let me do this while I am starting a conversation, and with some practice, yours will, too.

c. You also need to write the names down as soon as you get the chance. Writing the names will cement them in your mind, and will give you something to refer back to after the clients have left. Make brief notations about your conversation. Obviously, it would be inappropriate to pull out a notepad while you are in the middle of a conversation (who are you, Dick Tracy?). When I visit with collectors, I do a little dance where I spend a minute or two to introduce myself and become acquainted, after which I back off to let them look at the work. It's during this

"backing-off" phase that I quickly jot down their names.

Create a small customer form on your computer (or print it out) where you can make notes about customers, including their names, addresses, emails, phone numbers, and the pieces about which they seem most interested. Leave yourself space to make notes referencing your conversation with them.

d. Use the clients' names repeatedly in your conversation. "That's an interesting question," becomes, "That's an interesting question, Darlene. Bob, come over and listen to the question Darlene just asked about this piece." You might think this sounds a little over the top, but you will be surprised how natural it becomes with practice.

e. Study your mailing list. Once a month, sit down with your mailing list and briefly read through it. This refresher will serve several purposes: it will give you ideas of people you should contact to inform of new work; it will inspire

you to nourish an established friend-
ship or cultivate a new one; and it will
exercise your memory. I have had many
instances when a client has walked
through the door, and I was able to
greet him or her by name because I had
recently gone over the client list: this
even though the client hadn't been in
the gallery for months, or perhaps
years. I wish I could do this with every
client, but my client list is simply too
large. Those whose names I do remem-
ber after an extended absence from
the gallery, have become some of my
best long-term clients

5. Ask probing questions. When you are visiting
 with new collectors, you should spend the first
 several minutes trying to learn as much about
 them as you can. Asking them questions will
 not only help you tailor your sales effort to
 meet their needs, but will also tell your cus-
 tomers you care about them. Ask questions
 that require more than a mere yes or no an-
 swer. Here's a list of some of my favorite con-
 versation starters; you will see that none of
 them is a yes/no question:

a. Where are you from?

b. What do you think of your visit so far?

c. What business are you in?

d. What kind of artwork do you collect?

e. How long have you been collecting?

Questions such as these will invite conversation directed to particular avenues of interest. Which leads to the next point:

6. Ask follow-up questions. A significant step in this process of building better relationships with your customers is to actively listen to them. There are few better ways to demonstrate your attention than to ask perceptive follow-up questions:

"I've never spent any time in Nashville; what's the art market like there?", or "Oh, my good friend works in the advertising business; how long have you been at it?"

7. Listen to each response. I have heard sales-people ask a client where she's from one minute, only to inquire whether she lives in the area after her response that she lives in another state. Often the problem is that the salesperson is so focused on himself and his performance that he does not focus his attention upon what the client is saying. This is not a play in which you have your lines, and your client has hers. Rather, this is a conversation in which you can both gain information and build a friendship. Especially listen for that information which can provide you insight into what your client is seeking.

8. Turn the focus back to the art. Yes, it's great to build a friendship. But don't err on the side of spending too much time talking about the weather. Guide the conversation back to your art. Pull your collector from one work to another, and tell him the story of the creation of each piece, and express your enthusiasm about the results. Your enthusiasm is conta-gious, and when your collectors "catch your vi-sion", they will buy.

9. Help the client envision the art in her home. When a collector zeroes in on a particular

piece, it's time to help the collector visualize the artwork in her home. "Where would you display the piece in your home?" or, "Tell me about the space where this would best work in your home."

10. Ask for the sale. Often a sale vanishes into thin air for the simple reason that you don't ask for it. The decision to buy involves some risk for the collector. Is the work worth the asking price? What will friends and family think of the piece? Will the buyer still like the art six months from now? If you don't quickly transition the collector from the vision you've created of having the artwork in his life, to closing the sale, the doubts will creep in and the sale will disappear. To move the collector to buy the art, ask for the sale. "Can I wrap that up for you?" "Will you be taking the piece with you, or would you like me to ship it?" "May I write that up for you?" Be simple. Be direct.

11. Resolve concerns. Sometimes you ask for the sale and the client says she is not ready, making one excuse or another. Don't give up right away. Turn the client's concerns into an opportunity to provide extra service, while at the

same time turning a no into a yes. The more specific the concern, the better you should feel, because you will better be able to address it.

"We're not sure it will fit," or "The colors might not work," gives you the opportunity to take the work out to their home to let them see it in the space. At the very least, you are able to give them the measurements and a photo.

"It's too big," gives you the perfect opportunity to create a commissioned piece that will suit the client's requirement.

"It's more than we were planning to spend," gives you an invitation to negotiate the price (more about this will follow), devise a payment plan, or commission a smaller, less expensive piece.

"We just started looking," allows you to place the piece on temporary hold for the clients, because you would hate for them to lose it were someone else to fall in love with the piece before they get back with you.

12. Negotiate. I have worked with a few artists over the years who have dictated the set price, along with their unwillingness to discount it. In my opinion, this is a foolish and short-sighted position to take if one's goal is to sell art. Collectors have become more educated, and the savvy art buyers will *always* ask for a discount. Collectors understand there is some give in the value of artwork, and for many it is part of the excitement of buying to negotiate the price down. Some artists will say discounting devalues their work and hurts the market. Though I agree, we do have to face reality. Drawing a line in the sand and refusing to negotiate is only going to drive buyers elsewhere.

I admit that I derive tremendous pleasure from the process of negotiating. Excitement is generated as negotiations get underway, and I am thrilled when a collector asks for a concession on pricing because I know I am only moments away from closing a sale.

You should remember several things as you are negotiating:

First, both sides are working toward the same goal: the sale of the artwork in question.

Second, keep it positive. I have heard sales-people say: "I'm sorry, the best I can do is $2,500. . ." I cannot imagine a worse line when negotiating a sale. You are guaranteeing the death of the sale by assuming the client is not going to like the price you have to offer. If you have a $3000 piece and the client asks you for $1000 off, rather than assume the sale is over, transform the counter-offer into a positive. "It is my pleasure to offer the piece to you at $2,500, and I am happy to deliver and hang the work at no additional charge." Doesn't that sound better?

Third, don't talk in terms of percentage – keep the negotiations specific. If possible, write the numbers down to make them more real. I might say:

"The retail price is $3,000; with delivery and tax you would be looking at $3,240. It is my pleasure to offer the piece to you at $2,500, including tax and delivery."

I would write:

Retail: $3,000 + $210 (tax) +30 (dlvry)= $3,240

$2,500 (Includes delivery and tax)

The retail price now seems complicated and expensive, while the discounted price seems simple and affordable.

After negotiating the price, it is time to ask for the sale again. "Would you like to do that?", or "May I write that up for you?" are effective questions to facilitate the close of the sale.

13. Write it up now. Once the commitment to buy has been made, it is critical to immediately wrap up the sale. Don't dilly-dally around and give the collector a chance to experience buyer's remorse before he has even bought. Once you hear "yes", take the buyer directly to your desk or table to write the receipt.

14. Send a thank you. After the transaction has been completed, and the artwork delivered and installed, send a hand-written thank-you note at your earliest convenience. Keep it simple:

Dear Mr. & Mrs. Smith,

Thank you for your purchase of "Via Del Fuego." I know you and your family will enjoy the piece for many years to come. I appreciate your business and the confidence you have placed in me, and in my work. Please let me know of any way I may be of service.

Very truly yours,

Your Name

15. Ask for a recommendation. A month or so after the thank you note, send a follow-up note or email inquiring after the clients satisfaction with the piece, and requesting that they take a moment to share their feelings with your other collectors. The words of your satisfied clients will be among your most powerful tools in helping to persuade future buyers. A letter such as this will do the trick:

Dear Mr. & Mrs. Smith,

It's been a little over a month since you purchased "Via Del Fuego," and I am following up to make sure you are fully satisfied with the painting, and to assure you that if there is any way I may be of further service, you need only contact me.

I also would like to ask a favor. I would love to share what the art has done for you and your home with my future collectors. I have found that sharing my collectors' feelings about my art with someone who is trying to decide whether to buy, will help him feel more comfortable in purchasing my work. Your comments about both my work, and your experience working with me, would be invaluable.

As a suggestion, you might think about describing what the artwork does for the room, and how it makes you feel when you see it. You might also describe what visitors to your home have said about the work.

Thank you for taking the time to help me better share my work with other collectors.

Sincerely,

Jason Horejs

Artist

Though not all of your collectors will respond, the responses you do receive will be worth many times their weight in gold.

16. Make the client a collector. He who has already bought your work is your most promising future buyer. Cultivate him. Each client should automatically be included on your regular e-mail list and on your holiday greeting card

list. He should receive hand-written notes from you several times a year. Create a friendly, positive relationship with each client, and dedicate yourself to remaining on his radar. As time passes and he is ready to purchase additional artwork, he will now become your collector.

Learn to enjoy the sales experience. Remember you are helping people fulfill a real need to bring beauty into their lives. The collector is the one benefiting most from the purchase of your art. After all, you will likely have spent the proceeds of the sale in a matter of weeks, while she will have the artwork to enjoy for years and years to come.

CHAPTER 12 | AND NOW YOU KNOW WHY YOU WANT TO BE IN GALLERIES

After reading the last several chapters, you are probably saying to yourself, "That sounds like a lot of work". I am not going to lie to you . . . it is a lot of work. Most artists who have spent any time promoting, marketing, and selling their own work realize just how much work it is. When you realize all of your time is going into selling the work, you also confront a problem: there isn't much work to sell because you are not in the studio creating.

Indulge me as I make a shameless plug on behalf of galleries. We're pretty awesome. Our entire mission in life is to professionally market and sell your art to enable the pursuit of your life's mission: to create a body of work. With an effective support system, you will be creating more, working less, and *making more money.*

Galleries effectually reach the market as you simply never could. Galleries can have your work seen by collectors from all over the world, in multiple venues around the country, while you sip coffee in your studio.

If you are doing weekend shows, you have at most three days to make the connection and close the sale;

and think how often a simple factor like the weather can determine whether all of your effort and expense pays off. If you are in a gallery, your work is available to your collectors every business day of the week, every week of the year.

Typically, most artists are not natural salespeople. Wouldn't you enjoy the benefits of a professional sales staff working for you to sell your work?

Finally, showing in galleries lends an air of credibility and prestige to your work. Haven't you found that collectors and other artists frequently ask you in what galleries you are showing? Gallery representation is a certified stamp of approval for your work, and helps ease the minds of the collectors as they are deciding whether to invest in you as an artist.

I need not go on and on. You obviously already see the merit in showing in galleries, or you wouldn't be reading this book. I do, however, want to reinforce the certitude that you will be more successful showing in galleries than you will be promoting your work on your own.

In my recent survey, I found artists who do not show in galleries average $9,779 in annual sales, whereas gallery-represented artists average $55,470 in annual sales. Even with other factors impacting the sales figures, it remains clear that you have a much better chance of ge-

nerating sales if you work with galleries than if you work alone.

PART IV – FINDING AND SUCCESSFULLY APPROACHING THE RIGHT GALLERY FOR YOUR WORK

CHAPTER 13 |MAKE A PLAN AND DO YOUR RESEARCH

For a brief period in 1998-99, I worked as an artist's agent for a western sculptor out of Utah. I was responsible for putting together the artist's portfolio, his resume, and artist's statement, and then for approaching galleries with his work.

I was only 24 at the time, and had no idea how to approach galleries, despite the fact I had been watching my parents do it my entire life. Though I made a lot of mistakes, I gained invaluable experience that has helped me better understand the challenges the artist faces as he or she goes out into the world and tries to get gallery representation. Though the stint was brief and I soon returned to the gallery business, I was able to place the artist in two galleries.

That said, my brief experience is not sufficient to provide you a good game plan for approaching galleries. Instead I will draw from the experience of my parents as they approached galleries, and add my own insights from the other side of the court as a gallery owner who has been approached by thousands of artists.

My father decided he wanted to be an artist at an early age, and my mother quickly became not only his biggest fan, but also his business advisor and marketing manager. At the time they were married they lived in South Central Idaho, which is about as far as you can get from the center of the art universe. Being young and naïve, and having dropped out of art school, they decided they were going to take the art world by storm. My father had some innate talent, and a willingness and desire to expand his skills. My mother had an abundance of excitement, energy, and enthusiasm, and was not afraid to tell anyone who would listen about my father's work.

Not knowing any better, they started by showing my father's work in the local weekend "arts in the parks" shows. While they didn't experience much success with these shows, they were hooked on the business, and realized the need to get my father's work into galleries.

They soon developed a plan to accomplish exactly this. My mother calls their technique the "scientific approach to getting into galleries." The approach they developed has served them well through the years.

The first thing they had to decide was where to go. The logical choice would be to start with local galleries, but they were living in a little town in Idaho where galleries were non-existent. They did the next best thing and headed to Boise, which was the nearest "big" city. They

found a gallery to represent them there (details will follow), and then had to decide where to go next.

They had one clear option. My uncle worked for a small, northwest regional airline that would grant him buddy passes for family members. Those with passes could fly anywhere the airline flew for $10. So my parents put a map on the wall, placed pins in the cities the airline serviced, and headed for the first destination, Portland, Oregon.

Portland was a natural choice not only for the $10 fare, but also because my parents could stay there free with friends. They were literally starving at the time. Every penny counted. Careful planning was essential.

While you may not have a family member in the airline industry, the same principles apply:

Approach galleries in convenient markets first. Do you have family members you could visit regularly, or friends you would like to see more frequently? Does a spouse's job take him/her regularly to particular towns or cities? These destinations are ideal because you are already traveling to them. The frequency of your travel will make it convenient to stay in communication with your gallery. Returning often will serve to keep your face uppermost in the gallery owner's mind, and will provide the opportunity to update your pieces in her inventory.

Don't limit your search to primary art markets or major galleries. Before I meet with artists to advise them on marketing, I request that they fill out a brief questionnaire to share their vision of where they would like their work to take them, and to identify their goals. The most consistent element in the completed questionnaire is the artist's desire to show in New York, Los Angeles, or Chicago. This is understandable – one should have high ambitions; and what could be more fulfilling than having a solo show in a Soho gallery? With this in mind, why not make New York first on the list of markets to approach?

If one thrives on rejection and is armored with a thick skin, then by all means, approaching galleries in New York will be par for the course. If, however, the goal is to find good, strong gallery representation which will contribute to a remunerative relationship, a secondary market is a better place to start.

The United States boasts tens of thousands of galleries. While there are a plethora of galleries in New York, Chicago, and Los Angeles, there are galleries in most towns and cities across the nation. The aspiring artist is much more likely to succeed by first targeting the smaller markets. Make no mistake, the right gallery, even when outside the sphere of the New York scene, is going to sell more work than might be expected.

There is an advantage in being a bigger fish in a smaller pond. Think of venues like Santa Fe, Scottsdale, Denver, Atlanta, and Minneapolis. Consider places like Bend, Oregon, Boise, Idaho, and St. Louis, Missouri. Anywhere has the potential of harboring the gallery that will stake the artist in his or her career. Once showing in galleries in smaller markets, it becomes easier to transition to larger markets because a track record of sales has been established.

If perchance a brother lives in New York City, and he is visited twice a year, OF COURSE New York City is a target market. But there is little likelihood of the neophyte getting into a top New York gallery. Luckily, there is a full spectrum of galleries in New York City from which to choose.

Now to my parent's story, and a distillation of their scientific method.

Step 1, Compile a List. Once my parents arrived in Portland (or any of the other cities they approached), they went straight to the nearest phone booth, found the yellow pages, and gently removed the pages containing the listings for "Art Galleries and Dealers." The internet has made this petty larceny unnecessary, as a list of galleries can be compiled before boarding an airplane. My parents would go down the list and do a cursory review of the galleries. They crossed off the galleries that were

obviously not going to be the right fit — galleries specializing in Northwest Coastal Native American Art, in experimental contemporary work, or in photography. The galleries remaining on the list after the initial pass were the galleries to be researched by my parents.

Now the internet makes virtual visits to the galleries possible, enabling an artist to view the work they carry, and ascertain the potential for a match.

Step 2, Physically Visit The Galleries. With list in hand, my parents hopped into the car, and in as orderly a route as could be mapped, visited every gallery on the list. Their goal on their initial visit was not to approach the owner for representation, nor to get a foot in the door. This first visit was to be a scouting mission, and a kind of secret-shopping venture. My parents were in essence interviewing the gallery to see if it was a good fit for my father's work.

The battery of questions which they asked themselves included:

> **Is the gallery in a good location?** Is it a locale my clients would be likely to frequent?

Is the gallery well organized, with the artwork displayed in a professional and orderly manner?

Is the staff friendly and knowledgeable? Are we greeted when we enter the gallery, and does the staff seem attentive? (Regrettably, some galleries do not cultivate an air of approachability; in fact, some seem intent to intimidate. This approach may work for some, but it was not an approach in keeping with my parents' outlook on the art business. I have inherited their ideal — galleries should be friendly and service-oriented.)

Would the Gallery be a good fit for my work? This question is probably the most important, yet seems to be the most often overlooked by the artist as he approaches my gallery.

Scottsdale is known for western art, and there is plenty of it to be found in Scottsdale galleries. However, all one has to do to realize my gallery is not a western art gallery is take one quick glance around. Not a single cowboy, nor tumbleweed, nor

boardwalk. Not a single piece peculiar to the western genre to be seen. Yet it is amazing how often I find myself looking at portfolios filled with western subjects. To save both you and me, the gallery owner, precious time, and you certain rejection: do not approach galleries in which your work does not fit.

Another aspect of fit is pricing. If your work falls far outside the general pricing of the work in the gallery, it is going to prove difficult to sell. Too high and collectors are going to feel the other work in the gallery is a better value; too low and they will feel there must be something wrong with your art. Look for a gallery where both your work and pricing will be fits.

During this secret shopping experience, keep several things in mind. First, don't waste the gallery staff's time by portraying yourself as a buyer. When approached by a salesperson or owner, make it clear that you are just looking, and will let them know if you have any questions. The worst thing that could happen is for you to be mistaken for a big-shot collector, only to later be revealed as an artist. Your identity as an artist may come

out in conversation, and this is fine. Your goal on this first trip to the gallery, however, is to reconnoiter.

Second, especially when you are looking for a primary gallery, don't be too picky. Don't allow yourself to be impetuous in deciding that none of the galleries in a particular town offers a fit. If when you complete the initial internet search, you don't have a number of galleries to visit, you will need to refine and expand your efforts to put some possibilities on your list. The population of the region to be searched will likely determine the ultimate length of your list.

Third, learn as much as you can about the gallery before you visit. As mentioned, the internet makes this easy. With a little research, you can learn the gallery owner's name, the number and identities of the artists it represents, and a bit about the gallery's background. Your knowledge of the galleries in any given market will make your time more productive.

And now, upon the conclusion of your research, you are ready to initiate . . .

CHAPTER 14 | THE POWER APPROACH

You have a list of galleries you would like to approach. Now what? Do you mail them your portfolio, email them, or call to set appointments, as many marketing books would suggest? Do you visit their websites and follow their submission guidelines to the "t"? If you want to be rejected, employ any one of the aforementioned methods.

"But why would I be rejected?" you ask, "these approaches all seem to be professional."

True, but the problem is that by employing any one of these tactics, you are making it easy for the gallery owner to reject you. The scenario is a common one.

Owners are approached by a steady stream of artists looking for representation. Although few of the artists who approach us are well suited for the gallery, one out of every ten might be a good fit. In a year we could ostensibly take on dozens of artists, maybe even hundreds; but the reality is, we do not have the space to accommodate them. So we have to say "no," and we have to say it frequently. If you send me your portfolio in the mail, or email me, you have made it easy for me to reject you;

you are no more than a name or an e-mail address to me.

At times, I will have a stack of portfolios and cds from artists with no time to go through them. I admit there have been occasions when I have simply thrown the portfolios away. Perhaps if they came with a self-addressed envelope, I returned them without ever having looked at the work.

Emails are even easier. I have a template, whereby I hit reply, and you get the "we're-so-sorry-your-work-is-great-but-we-don't-currently-have-any-space" email. Yes, it is just a blow-off, because we can always find space for artists we know will sell.

So if emails and mailed portfolios don't work, how about calling ahead to set up an appointment? "We only look at new artists in the summer" (or if it is summer, I will say winter), or "I am just too busy." Whatever I have to say to manage the number of artists approaching me, I will say it.

"Well, then," you say, "I will go to your website and follow the submission guidelines I find there. You can't possibly have a complaint about that strategy; after all, you posted the guidelines."

True . . . but my reasoning for guidelines on my website is to discourage you, to even forestall you. I am se-

rious. When my director and I placed submission requirements on our site several years ago (our website has since changed and the page is now gone), our sole purpose was to reduce the number of submissions we received. We made the requirements obtuse and demanding in order to encourage visiting artists to move on to the next gallery. It doesn't really matter to me that your images be sized to 1920 x 1920 pixels, or that your resume be limited to two pages, in 12 point font, and single spaced. The page was up on our website for over a year, and in that time I received only one submission which met all of our guidelines (and no, that artist did not find representation with my gallery).

Candidly, all of these approaches are destined to result in very few prospects for representation. I won't advise that you never distribute CDs of your work to galleries, nor that you never follow the guidelines for submission on a website. What I will advise, however, is that you not rely upon these mechanisms as your primary approaches for securing gallery representation. You don't want to mail out hundreds or even thousands of CD's before you get a bite. You don't have the time to jump through all the hoops required on website submissions.

Why waste your precious resources? You will be better served by throwing your best pieces in the car, driving

to Denver (or wherever), and approaching the gallery **in person.**

Shocking, I know, and maybe intimidating; but if you are standing in my gallery and making a personal connection with me, I am, at the very least, going to be willing to look at your portfolio and give you a few minutes of my time. Your physical presence makes it difficult for me to say "no" prior to a look at your work.

The approach itself is going to be simple. You will take your portfolio in hand, and walk confidently into the gallery with a pleasant smile on your face. Extend your hand to the first official you see (in most cases this will be an owner or director), and say:

"Hello, my name is _____, and I am a professional artist from _____(city)_____, _____(state)_____. I am in town looking for gallery representation. Do you have a moment to look at my portfolio?"

As you are are finishing the last sentence, you will proffer the portfolio and wait expectantly. In the majority of cases, the portfolio will be taken, opened, and reviewed.

This approach has been carefully crafted and readily handles a number of important tasks. First, by giving your name and letting the gallery know you are a professional

artist, you are giving an air of confidence that inspires others to take serious notice.

Second, by letting them know you are from out of town, you are creating a bit of mystique and interest. You are also letting them know you are here on a specific mission, and that you require immediate feedback on their part because you have limited time in which to procure gallery representation.

Third, by specifically stating you are in town looking for representation, you are making it clear that you are seeking more than a critique of your work, and more than agreeable conversation. Indeed, you are looking for someone to represent you.

Fourth, by stretching your arm out to bestow your portfolio, you are making it awkward for the owner or director to refuse. He is going to accept the portfolio and begin to look at your work.

Finally, as the director pages through the portfolio, you have an essential job to do:

Shut up!

We are all human, and if there is one thing we abhor, it is silence. This silence will be especially difficult to endure while someone is looking at your work with a critical eye, and you have no idea what he is thinking.

Your tendency will be to fill the void, and you will do it (if you are anything like the many thousands of artists who have approached me over the years) by voicing a flurry of explanations of your work, the awards you have won, the procedures for mixing your colors, and on-and-on. There will come a time and a place when all of this information will be shared—now is not that time.

Remaining silent while the gallery owner looks at your work serves to place the pressure upon him. The ball is now in his court, and it is up to him to fill the silence with pertinent questions. Use this silence as a tool, and prove the old sales adage: "the first person to speak loses."

The gallery owner will make comments about your work, and ask you some questions. If the work is within his/her realm of interest, the conversation will head in a positive direction. Keep your answers concise and up-beat. Often, it is not so much your answer, but how you answer, that matters most.

Step into my head for a moment to better understand what a gallery owner is thinking as he looks at your work. I am asking myself four questions as I review an artist's work:

1. Do I like the work? This is a visceral reaction. If I think the work is cool and unique and am excited by it, I will probably be able to create a similar ex-

citement in my collectors. If, on the other hand, the work does nothing for me, it matters not how famous the artist is, nor how trendy the style; I'm not going to be able to get behind the work and sell it.

2. Will the work appeal to my collectors, and will they buy it as priced? I can't answer these questions with absolute certainty, but having been in the gallery business for half my life, I can be right more times than not.

3. Do I like the artist? Life is too short, and there are too many good artists out there for me to represent an artist who is difficult or disorganized. I am looking for artists with whom I can build long-term relationships, who are friendly, and on top of their game.

4. Is there a niche for this artist in my gallery? Does the work feel like it will fit? Is it too close in style or substance to other artists I carry? Will it fill a niche for price, subject, or size?

The gallery owner briefly directs his attention to your work, and formulates a judgment which could have lasting repercussions for the gallery.

While each gallery asks a different set of questions, the substance is uniform: "How much have you sold?"; "Are you seriously pursuing your work?"; "If your work sells well, will you be able to replace it?"; "How much work have you created in the last year?"; "How many galleries represent you?"; "What is your background?"

Answer the questions honestly, composing your responses to show yourself in a professional light. Consider, for example, the question: "How much work have you sold in the last year?" Perhaps you have not sold much in the last year. Never-the-less , do not respond by saying, "I'm afraid sales have been slow for me the past year," nor by deprecating yourself with flimsy excuses. Keep your response positive and concise: "In the last year I have increased my sales by 50%, and can no longer spend my time in marketing my work. Frankly, I need to be in the studio painting."

While you did not answer the question precisely, you did let the owner know you are increasing sales, and that you need the gallery to do the marketing you are now too busy to do.

Don't mistake a question for an opportunity to ramble on for an hour – answer and get on with it. Time is of the essence.

* * *

Ask other artists you know how they got into the galleries they are in, and you will hear many different stories. However, the stories will invariably detail the approach perfected by my parents, and submitted by me to you.

Other issues to consider in the quest for representation:

> **Your dress should be business casual.** Don't over-dress: a suit and tie, or Sunday best and heels, feel like you're trying just a bit too hard. Most artists I know would feel uncomfortable in such attire.

> **Don't assume failure before you even walk into the gallery.** I have too many artists approach me with slumped shoulders and a glum intro: "I know you are probably too busy to look at my portfolio. I never do stuff like this. You probably don't have space to show my work, but could you take a quick look anyway?"

> ". . . You're right," I say, "I am too busy to look, and I don't have space."

Don't presume to know what I am looking for, or how I will view your work. Let me make my own assessment.

Don't lay the compliments on too thickly. Praise beyond "You have a beautiful gallery," becomes unctuous and self-serving.

Look me in the eye and use my name. The same sales principles apply in selling your work to a new gallery as to a collector (see Chapter 11). Make a connection with the person to whom you speak. A gallery owner is more likely to take a risk with someone who comes across as bold and confident. Look me in the eye and call me by name to convey an impression of strength.

Smile. Did I already say that?

Carry actual samples of your work. This may prove difficult when you travel a great distance to visit the galleries, but tangible samples of your work will increase your chance of getting into the galleries you approach.

I have personally hung work in the gallery on the same afternoon I met an artist for the first

time. In fact, in 2003, we were approached by an Arizona artist who created vibrant, desert botanical paintings. She showed us her portfolio, and then brought in a number of pieces and leaned them against the wall. Before she left the gallery, two of the pieces were sold to a collector from Texas. At first I suspected she had hired a friend or family member to come in and buy the pieces to make herself look good. This, however, was not the case, and the collector went on to buy several additional pieces from us.

There is something electrifying about having new work in the gallery; if you can be prepared to supply this electricity, by all means, do.

If, however, it is not possible for you to travel with your work, don't despair. You and your portfolio can get the job done, and you can ship the work when you get back to the studio.

Do not show the gallery samples of smaller works if smaller works are not what you normally do. Seeing work that is not typical of your best-selling work will not help make the sale to the gallery. You want to put your best foot forward.

Do not put all of your eggs in one basket. Occasionally, a gallery owner will take your portfolio and tell you he needs to sleep on it, or confer with an associate, or whatever. That's fine, and assuming you have several copies of your portfolio, you will leave one. However, you will not cease to contact the other galleries on your list before you have a consignment agreement in hand. Always ask when you may return to learn the gallery's decision regarding representation.

If you are lucky, you will have happen what happened to Tammy Bality, an artist I met in Denver last year. Tammy went to Jackson Hole looking for a gallery, following some of the methods I have suggested. The first gallery she went to was interested in the work, and asked for some time to review the portfolio. Tammy allowed them to keep a copy, but continued to visit other galleries on her list. The second gallery passed, but the third gallery enthusiastically signed a contract, and had her work displayed that afternoon. It was particularly gratifying for Tammy to return to the first gallery and ask that her portfolio be returned, as she had already signed with another gallery.

Be persistent. Don't assume because you approached all of the galleries in town and didn't find one that agreed to show your work, that you are doomed to failure. Forget the notion that it's time to go back to selling insurance (or whatever it was you were doing to make ends meet prior to pursuing your dream).

After you go home, write thank you notes to all of the gallery owners you approached. Include an image of your work with the notes. Thereafter, send an email with an image to the galleries every few weeks. You never know, perhaps the galleries lacked space for additional art at the time, and your repeated contacts will ensure consideration in your behalf when they are ready to show new work.

Don't take rejections personally. I advise you to develop a thick skin in the process of approaching galleries. The first rejections can be incredibly painful—some artists never recover to continue their pursuit to secure gallery relationships. I received a note from an artist lamenting the refusal of his work by four galleries. FOUR! Four is just a warm-up, folks, and does not comprise a complete effort. The rejections of forty galleries should not defeat

you. When I am asked how many galleries an artist should approach when seeking representation, my answer is simple and consistent: "As many as it takes."

I understand this entire exercise can be agonizingly personal. It is akin to having someone look into your soul; when he rejects your work, it is as though he is rejecting you. Don't look at it that way; rather, realize the gallery owner is doing you a favor by not showing your work if he thinks it will not sell in his gallery. Find a gallery that is going to be excited enough about your work to market it.

Don't allow the war stories of others, nor the inevitable disappointments of your own, to dampen your enthusiasm. Stay the course. Your persistence will ultimately be rewarded.

Practice makes . . . One sure way to get plenty of practice at the gallery approach is to get on with approaching galleries; seems logical, doesn't it? If you think about it though, that's somewhat like the basketball player waiting to practice until game day. Preparation by way of practice allows you to "hit the court." I will set the scene to get you started, and I want you to

run this scenario in your mind a million times prior to setting foot in a gallery.

If you have an understanding spouse or friend, you have a practice partner. Ask your partner to play the role of gallery owner, and run through the approach in rehearsal a number of times to get a feel for what the experience will be like. The more you practice physically, the more you will become comfortable with your role, and with what you are trying to accomplish. You will also be better able to anticipate questions the gallery will ask you, and how you will respond.

The Approach – A Play in One Act

The Cast

Professional, well-organized Artist (you)

Gallery Owner

The Scene

A street in Columbus, Ohio

Our protagonist, the artist, stands on the street corner outside a beautiful contemporary gallery and takes a deep breath, puts on a gleaming smile, and walks in the front door. The artist glances around the gallery and sees only one person, who is reading a brochure at the far end of the gallery. The artist moves forward, resolute, toward the desk in the middle of the gallery, where a handsome, sophisticated man sits working on the computer.

Our artist feels a burst of adrenaline, and heads for the desk. The gallery owner looks up and stands as the artist approaches.

GALLERY OWNER:

Yes, may I help you?

ARTIST

(holding out hand to OWNER across the desk)

Yes, my name is Michael Jones. I am a professional artist from Minneapolis, MN. I am in town for a day, looking for gallery representation. Would you have a moment to look at my portfolio?

OWNER:

(taking the Artist's hand)

Hi Michael, I'm Peter. Sure, let me see.

(stands and takes the portfolio and begins to thumb through the pages.)

Hmmmm.

Interesting.

How long have you been painting?

ARTIST

Over seven years now.

OWNER

How does your work sell? How many pieces have you sold in the last year?

ARTIST

Well, I paint full-time, and I am able to create two pieces a week, on average. I am selling most of my work every year.

OWNER

I see. Do you show in any galleries?

ARTIST

I have focused on shows for the last several years, and have built a considerable collector base. Frankly, I'm ready to focus all of my time on creating, and would like to leave all of my marketing in the galleries' hands.

OWNER

It's strong work. Do you have any examples of the work with you?

ARTIST

I flew into town, so I don't have any pieces with me, but if you are interested in seeing them, I would be happy to ship several to you. I also have a website that shows additional work.

OWNER

And do you sell from your website?

ARTIST

I have sold over $10,000 in work from my site over the last seven months, but I would like to refer all of that business to my galleries. Should you choose to represent me, I would refer all of my webtraffic to you and to other potential galleries.

OWNER

Hmmm. Well, I find your work very intriguing. Your style is different from any of the other artists I am showing right now, and might be appealing to my collectors. I would be interested in showing your work.

ARTIST

Terrific! How would you like me to proceed?

OWNER

Well, why don't you send me images of available work when you get home, and we'll see if we can find the right pieces for the gallery. How many pieces do you have available?

ARTIST

I have 25 gallery-ready pieces. Would you like me to email the images to you?

OWNER

That would be great.

ARTIST

How many pieces do you generally keep on hand? Do you have a standard consignment agreement?

OWNER

We usually ask to have 10-12 pieces in inventory. Let me give you a copy of the consignment agreement. You can read it at your leisure, and send a signed copy with your first pieces.

ARTIST

Wonderful. I love your gallery and will be honored to show here.

THE END

This of course, is not the end, but only the beginning. While this is a simplified version of what you can expect, it is fairly close to conversations I have had with many artists, and to the conversations I have heard between other gallery owners and artists.

The key to the whole process is to relax, be yourself, have a natural conversation, and let the work speak for itself. Remember, by this point you have already invested the necessary time and effort to be prepared, and the actual approach is going to be smooth and exciting.

CHAPTER 15 | CONSIGNMENT AGREEMENTS

Now that you have found a gallery to represent you, it is time to delve into the intricacies of the business relationship you will be establishing with your gallery. Because most galleries are small, family-owned businesses, there is no industry standard operating procedure. Each gallery is a country unto itself. There are, however, some general rules and issues you ought to be aware of as you begin to negotiate a contract.

Now for my disclaimer. My intention with this book is to give a general overview of the gallery business, and to offer suggestions for the process of selling your work through galleries. My intention is not to offer legal advice: I would have been a lawyer if I wanted to do that. If you have specific questions regarding the terms of a contract with a gallery, you would be well advised to consult a legal professional.

There is tremendous wisdom in associating with galleries who offer a written agreement. The greater the number of concerns covered in writing, the fewer the occasions for confusion or disharmony. In the art business, a simple handshake often suffices to seal a deal. However, there is much to be said for having essential

details in writing. If a gallery doesn't have a written consignment, consider creating one, and proposing that they sign it.

Following is a list of common terms used in a consignment agreement. They are listed in order of importance, and are defined and explained.

Commission Percentage. The typical commission galleries will take from the sale of your work depends upon your medium. It may also be determined by the location of the gallery, the age of the gallery, and by fluctuations of the local market. It is standard for galleries to take a 50 percent commission on the sale of two-dimensional work (paintings, photographs, digital work, etc.), and between 33 percent and 50 percent on three-dimensional work (sculpture, glass, mixed media work). Typically, a gallery is reluctant to negotiate its commission rate.

I have heard many artists complain about the high percentage, but I do not deem the complaining to be worthwhile. I could go into a long-winded diatribe about all of the work we do for the artists, the expenses we incur with rents, employees, marketing, etc. (our overhead is horrific). But I don't want to open a dialogue that puts gallery owner against artist, with each defending his position with points of questionable merit. No real purpose is served by a debate on this issue.

Galleries charge the commissions they do because they can. The benefits of gallery representation have been covered: the freedom to create, professional sales experience, marketing, prestige, etc. Whether it is worth the 33 to 50 percent commission to be in a gallery is strictly up to the artist.

Terms of Consignment. Some galleries will set a specific term on the gallery/artist relationship. They may require that work remain with the gallery for a minimum length of time—six months, a year, or two years. The reason behind such a clause is fairly simple: the galleries hate to invest marketing dollars in your work without a guarantee they will be able to capitalize on the investment. Often it will take some time for sales to result from display and marketing, and galleries don't want you to pull out before the sales begin.

Other galleries write their contracts "at-will", which means you may pull your art at any point, and likewise, the gallery may ask you to leave at any point. For an emerging artist, the "at-will" contract is common. It grants both the artist and the gallery the flexibility to call it quits if the relationship does not prove mutually advantageous.

Terms of Payment. The standard consignment agreement will allow the gallery 30 days from the time of the sale to remit your commission. This 30 day time frame allows the gallery to assure the artwork is not going to be returned, and that the payment has cleared. Some galleries will pay more rapidly, but most agreements will be written to specify the 30 day term.

Discounts. The gallery will likely ask the artist for some room to move off the retail price if discounting becomes necessary to make a sale. Typically, the wording states that the gallery has latitude to give a discount at the sole discretion of the gallery (a percentage ceiling is specified), with the discount to be shared equally by the artist and the gallery. Thus, commissions will be paid based upon the selling price, not the retail price.

Discounts can become a thorny issue when either party lacks a clear understanding of the transaction. I remember one young artist I worked with who could not abide discounts. She insisted her work was worth what she asked, and was sorely offended by a collector's request for a discount. To be fair, her work was reasonably priced; but fair or not, this attitude failed to address a reality of the art business: collectors want to negotiate. Collectors have become increasingly savvy; they know to ask if the retail price is the best price they can get on the

work. Many collectors opt to walk away if there is no negotiation. If an artist is unwilling to discount, potential sales are severely limited.

I look at discounts as one of the tools available to help me make a sale. Negotiating is one of my favorite parts of the business—I love the back and forth, the adrenaline, and the ultimate triumph when the sale goes through. Friendly negotiation makes everyone feel like a winner: the collector, the artist, and the gallery.

The negotiation becomes part of the collector's story. "We were in Scottsdale, where we found a beautiful painting we fell in love with at first sight. We were able to negotiate a great value. It was the highlight of our vacation."

Though the gallery sets the percentage up to which they may discount at their discretion, there are instances where the negotiations reach a standstill at a point beyond that percentage. Occasionally, it makes sense to move beyond that ceiling in the service of closing a deal. My solution is simple: I call the artist if I need to go beyond the standard discount. I do this out of more than consideration for you. I make the call because I like the client to feel that we are on the same team, working together to get her the art she loves. The artist plays the role of the bad guy in this scenario, but soon enough becomes the hero when he approves the discounted price.

In the event a gallery owner asks the artist if he is willing to discount, his reply ought to sound a lot like this: "Jason, my goal is to get as much of my art into art lovers' hands as I can. If that means we have to negotiate a discount, so be it. Let's not let the price be a stumbling block."

Exclusivity. Galleries will typically require an exclusivity clause, which gives them the right to be the sole marketer for your work in a given geographic area. This exclusivity might encompass a certain radius (100 miles, for example), a metropolitan area, a state, or even a multi-state region. The purpose of this clause should be obvious: galleries don't want their marketing dollars expended in making sales for other galleries.

If the gallery's exclusivity request seems too broad, and thus unreasonable, this portion of the consignment should be discussed. Especially in a home state, an artist has the expectation to show his work in other cities of close proximity.

The exclusivity clause is also likely to contain language limiting the sale of work on the internet (see chapter 9). The gallery has the right to implement safeguards which prevent the artist from directly competing through online sales. I see this as one of the great battlefields of tomorrow: galleries and artists are going to wage war over

their competing interests in the origination of sales. Though the artist might be reluctant to give up this source of revenue, the gallery will certainly be more reluctant still to invest in marketing his work. No one would expect the gallery to tolerate a negative return on its investment when buyers go directly to the artist online.

It is in the artist's best interest to reassure his gallery that he is not interested in making personal sales. A statement of his intention to direct all sales queries to the gallery is in order.

Insurance. The gallery is financially responsible for the loss, theft, or damage of your work. It commonly carries insurance to this end. Few galleries require their artists to carry their own insurance.

Insurance is a significant concern. One naturally feels more comfortable when the gallery carries a policy that indemnifies him for the replacement value of his work.

Shipping. Who is responsible for the cost of shipping artwork from the studio to the gallery, and back from the gallery to the studio if the piece doesn't sell? Traditionally, the artist has been responsible for getting the work to

the gallery, and the gallery has picked up the cost of return. Today, however, more galleries are asking the artist to take responsibility for costs in both directions. Fair or not, this is becoming standard in the industry.

* * *

The consignment agreement typically contains additional legal mumbo-jumbo about ownership, title, accounting, default, etc. My father-in-law is an attorney, so our contract has a fair amount of fine print. If one has questions about the specifics of an agreement, she should consult a lawyer.

Artist advocates often advise their clients to negotiate for better consignment terms. The more established artist is more likely to be successful in such a negotiation. The up-and-coming will find it difficult to make any changes in the agreement. If she feels she is at a distinct disadvantage, the artist is compelled to look for another gallery.

Will a consignment agreement protect you completely if the gallery goes out of business, or is delinquent in sales commission payments? Legally, yes . . . practically, not so much. The truth is, the expense in legal fees to litigate the terms of the agreement often prohibits the remedy of a lawsuit. Only when the amount of money in

question far exceeds the expense of litigation is suing a viable option.

The main purpose of a consignment agreement is not to protect contenders in a worst-case scenario: rather, it is a document setting forth guidelines to formulate and regulate the artist/gallery relationship. The more specific the language of the agreement, the less the potential for disagreement. Clarity in this document is essential to the success of the artist/gallery partnership.

Be apprised of this reality: when working with galleries, one is by definition in business, and as with any business, risks are incurred. Also accept that reputable galleries do not seek to take unfair advantage of their artists. Open communication is the best solution to avoid dispute.

Electing not to partner with galleries results in the greater risk. The work accumulating in the studio is not likely to market and sell itself.

If you would like to conduct a background check on a gallery, consult artists who are associated with the gallery to ascertain their degree of satisfaction. Ask about impressions of the gallery. Is the operation of the gallery well organized? Is there plenty of traffic? Is work actively marketed? What is the turn-over in artists? What is the rotation schedule in art displays? How quickly can one expect payment for sold work? Their candor in sharing

personal experiences will enhance your ability to ascertain whether this gallery is a comfortable fit.

No one knows so well the character, reliability, stability, and civility of a gallery as does the artist it represents. Use her as the primary resource in parsing through the gallery alternatives.

I include below a sample consignment agreement to give you an idea of what to expect.

SAMPLE CONSIGNMENT AGREEMENT

Agreement made Sunday, August 16, 2009, by John Painter (Consignor) and XYZ Gallery, L.L.C. (Consignee).

1. Consignee agrees to receive or has previously received goods from Consignor which shall be or are described on a "Consignment Schedule" in the form attached as Exhibit A to this agreement. These goods shall be the property of Consignor until sold.

2. Consignee agrees at its sole expense to keep Consignor's goods and display them as part of Consignee's business. Display and rotation of goods shall be at the sole discretion of Consignee and may include display of goods in homes or locations of prospective buyers. Consignee shall return goods to the Consignor on demand at any time before the goods have been sold. If goods are

displayed out of Consignee's premises for a prospective buyer, such goods shall be considered sold until they are returned to Consignee's premises for purposes of any demand that goods be returned. Goods shall be returned in good order and condition. Consignor may, at its sole discretion, request the return of goods from the Consignee at any time.

3. The Consignee agrees to keep accurate records of all sales of Consignor's goods, and to render an accounting of all sales and make payment to the Consignor within 30 days of any sale. Consignee shall pay to Consignor an amount equal to 50% of the sales price of Consignor's goods before costs of shipping and taxes. Consignee shall not be required to maintain funds payable to Consignor separate from Consignor's general funds.

4. Consignee may in its sole discretion elect to discount any of Consignor's goods by not more than 15% of the "Retail Price" shown on the Consignment Schedules between Consignor and Consignee for the purpose of making a sale. The "Retail Price" for purposes of calculating the amount payable to Consignor shall be based on the actual sales price including any discount.

5. Consignor may enter Consignee's premises at any reasonable time to inspect Consignor's goods and reconcile sums due.

6. Consignor grants Consingnee exclusive right to sell his artwork in the state of Arizona. Consignor will not show work in other galleries, in art shows, or in any other venue within Arizona.

7. Consignor agrees not to sell artwork directly to clients via the internet, or in any other manner if that client has visited XYZ Gallery.

8. Consignor shall retain title to all goods delivered to Consignee until such goods are sold in the ordinary course of Consignee's business, at which time title shall immediately transfer to the buyer.

9. This agreement is not assignable, and may not be orally modified: all modifications must be in writing. The members of XYZ Gallery, L.L.C. are not individually authorized to modify this Consignment Agreement without a writing, so any modification will require a writing.

10. Consignor represents and warrants that Consignor has title to all goods delivered to Consignee pursuant to this agreement.

11. This agreement shall be binding upon and inure to the benefit of the parties, their successors, assigns, and personal representatives.

XYZ Gallery, L.L.C.,

PART V – BUILD ON YOUR SUCCESS

CHAPTER 16 | YOU'VE ONLY JUST BEGUN

Now you know how to successfully approach galleries – so you know everything you need to know, right? Wrong! The truth is, getting your work into a gallery is only the beginning of a life-long journey. Whether your dreams are small – to be able to pay for your materials and fund your art habit—or grand– to become world-famous and show up in the history books, it will be necessary to promote your work, create sales, and expand your representation.

Once partnered with a gallery, it becomes imperative to improve quality, increase knowledge, hone skills, burnish reputation, and ramp up production. Earn the title of the "artist that sells."

The content of this chapter, and the chapter that follows, will delineate the strategy of the successful artist in sustaining a lucrative relationship with his gallery. Heed and succeed.

SERVICE, SERVICE, SERVICE

This mantra is the key to the castle. Regard your gallery as your best customer —this is exactly what it is. Each time you contact the gallery, ask: "What can I do to be of service to generate more sales?"

Implement the following suggestions to engender an association of approbation:

Communicate. Some artists seem to fall off the face of the earth once their work is delivered. I have worked with artists who may not make contact with the gallery for a year or even longer. The simple fact is an artist who is out of touch for that long is going to be the artist whose work finds its way to the back of the gallery.

You should call or email at least once every six weeks. The call is not going to be a "why-haven't-you-sold-anything" kind of call, but a "what-can-I-do-for-you" kind of call.

In most cases you will find the gallery owners you work with and their staff will become your friends, if not practically family members. The relationship will be built upon healthy communication.

Ask the galleries for feedback on your work, both what they think of it, and what collectors are saying.

Let your galleries see new work. Continue your email updates throughout your gallery tenure. Continue to elicit the gallery's excitement about your work, and their commitment to sell it.

New work can be a dynamic catalyst for sales. Every couple of weeks, everyone on your mailing list—former clients, gallery owners and staff, new contacts, etc.—should receive an email depicting the latest work. "Here's my latest piece. Please let me know if it would be a good fit for one of our collectors."

Keep your work fresh.

New work in a gallery is often the most likely to sell. A fresh piece excites the gallery and brings a burst of energy. I often feel like it's my birthday as I unwrap new work, and I have the desire to share my presents with collectors!

Rotate your work from gallery to gallery. It is wonderful when high sales dictate the rotation. However, when pieces linger in the gallery longer than six or eight months, it is wise to move them on to another gallery, where they become new again.

Never make demands of the gallery. Instead, offer suggestions. When you have ideas about how your work ought to be displayed, or about which pieces might work well together, the phrase "you should . . .", is never as effective as "what would you think if . . .".

Send a thank-you note. As soon as payment is received for a piece of artwork, dash off a handwritten thank-you note. In this age of impersonal emails and text messages, a handwritten expression of thanks will let the gallery know how much you appreciate its efforts.

My parents have gone a step beyond the thank-you note, though they continue to send them religiously. Several years ago, they set up a simple website which only the galleries can access. The site displays and categorizes dozens of small paintings and studies. Whenever one of my father's pieces sells through a gallery, the salesperson who made the sale is invited to select a painting or study from this website. My parents ship the painting to them as a thank-you gift.

What a powerful incentive! People who work in the industry have a great love for art, but cannot always afford to collect as much as they would like. The reward of a sample of my father's work serves to reinforce their regard for his creations, and inspires them to push his work at every opportunity.

Ask for a show. A show constitutes a terrific marketing opportunity. It provides an excuse to create more work, gives the gallery an opportunity to market the artist, and grants the collector an occasion to buy. The gallery generally maintains a "special events" calendar, and is happy to accommodate the artist who requests to post a date for a show.

CHAPTER 17| LEVERAGE YOUR RELATIONSHIPS

A little arithmetic will demonstrate that a single gallery is unlikely to generate sufficient sales for a professional artist to achieve his financial goals. The benefit of showing in a number of galleries throughout the country becomes obvious. Apply the principles outlined in this book to achieve a wide breadth of representation. There is tremendous advantage to be reaped in having cultivated a partnership with the first gallery: One is now a gallery-represented artist. The most challenging gallery in the world to get into is the first gallery—following the first, doors are more readily opened.

Be diligent in taking good quality photos of your work hanging in the gallery. Add these to your website and to your portfolio. Append links to your galleries' websites, and refer visitors to your gallery representatives. Once your sales with a gallery constitute a viable track record, request a written recommendation or testimonial in your behalf. Most galleries are happy to oblige. Offer to write the draft, and have the gallery print and sign it on their letterhead. This letter is a powerful asset to your portfolio, in conjunction with your resume. Each gallery with

whom you show should be invited to contribute a letter of recommendation.

An effective letter will mention how wonderful you are to work with, how much collectors enjoy your work, and a valuation of your gallery sales from the previous six or twelve months.

Move forward systematically. When your studio inventory cumulates 25 pieces, it is time to step forth and solicit an additional gallery. The sky is the limit.

PART VI – TYING IT ALL TOGETHER

In summary, the recommended actions which are sure to generate the greatest payback follow. It's almost time to put this book down, and to get on with the actual orchestration and implementation of our winning game plan.

Create a Body of Work

Two-dimensional artists should create a body of 20 to 25 gallery-ready pieces, and three-dimensional artists should have 10 to 15 gallery ready pieces (See chapter 4).

Update your Portfolio and Website

As your body of work grows, create a simple, well-organized portfolio (See chapter 8) and a professional website (See chapter 9).

Do your Homework

Plan a gallery-getting trip, and research the galleries in the market. Start with your local market if you deem it worthwhile. Spend some time on the internet to aid you with your selection of potential galleries. Eliminate the galleries that clearly do not fit, and focus on those that appear promising (See chapter 11).

Get out There and Do It!

Finally, get out your door with your portfolio, and start talking to galleries. I have met too many artists who have spent their entire lives getting ready, only to procrastinate the day of action. Don't let this be you.

How many times have you been walking through a gallery and said to yourself, "My work is better than this!

Why is my work piling up in my studio, while these lesser talents are showing and selling in galleries?"

The answer is simple—they got out there and successfully approached their galleries. Which is what you are going to do, too!

Follow your dream; share your work with the world. Allow the beauty of your creations to enrich the lives of your collectors. No one can do it for you.

NOTE TO MY READERS

Thank you for reading "Starving" to Successful. I look forward to your future success. Please let me know how the book has helped you further your career. Share your stories of success (or failure!); I'd love to post them to my art marketing blog. Let me know if you have any questions.

My direct e-mail address at Xanadu Gallery is: Jason@xanadugallery.com. My inbox is always full, but give me a few days, and I will get back to you!

Also, do take a moment to visit my website at www.xanadugallery.com, where you will find the artists I represent, as well as additional information about how to succeed as an artist.